Carsten Höller

Decision

SOUTHBANK CENTRE **HAYWARD PUBLISHING**

Ralph Rugoff

Foreword

For the past 25 years Carsten Höller has been making work that adventurously expands our ideas of what art can be and the types of experiences it can offer. Aimed at undermining our unquestioning faith in conventional ways of seeing the world, Höller's art engages us in alternative modes of perception that excite doubt and wonder, and that defy the hold of the familiar and predictable. While it can take forms that are unapologetically entertaining, it is also deeply thoughtful, often disorientating or disturbing, and deceptively subtle. Höller's approach to art-making is also remarkably generous in its address: frequently involving some element of direct participation by gallery visitors, it also acknowledges their presence as a key element of the exhibition. As the artist himself has said, 'The real material I am working with is other people's experience.'

Organised for the Hayward Gallery in close collaboration with the artist, *Carsten Höller: Decision* brings together many of the salient themes and motifs that have defined his artistic evolution over the past two decades. As the title suggests, the exhibition explores the ways in which we make decisions – or fail to. Beginning with the choice offered by two different entrances into the Hayward, visitors are repeatedly confronted with decision-making opportunities. At the same time, many works in the exhibition engineer unsettling moments of uncertainty in which we may find it impossible to make decisions of any kind. Ultimately, it is this space in between decisions – when we remain open to varied perspectives and possibilities – that the artist invites us to embrace.

This adventurous exhibition, which includes several major new commissions, could not have been realised without the support and assistance of many individuals and institutions. For their generous support of *Carsten Höller: Decision*, we wish to thank: LUMA Foundation, The Henry Moore Foundation, Gagosian Gallery, Galerie Micheline Szwajcer and Mondrian London. In addition I wish to acknowledge the valued contributions made by our commissioning partners Bonniers Konsthall, Stockholm, HangarBicocca, Milano, and Fundación Botín. We are also very grateful to the lenders to the exhibition (a full list of lenders appears on p. 107), and to the invaluable assistance of the artist and his wonderfully capable studio manager Stefanie Hessler.

On the Hayward curatorial team, Assistant Curator Dina Ibrahim confidently took on a daunting range of tasks and delivered all with precision and aplomb; Assistant Curator Rahila Haque did an excellent job organising a number of the outdoor projects in the exhibition as well as the talks programme; and Curatorial Assistant Charlotte Baker ably provided indispensable support on many fronts.

For their incisive and utterly original stories about decisions that feature in this catalogue, our thanks go to a brilliant group of authors: Naomi Alderman, Jenni Fagan, Jonathan Lethem, Deborah Levy, Helen Oyeyemi and Ali Smith. Hayward Publisher Ben Fergusson did a remarkable job overseeing all aspects of this publication. Wayne Daly earned our gratitude with his cannily conceived catalogue design.

I also wish to thank Hayward Operations Manager Thomas Malcherczyk and Senior Technician James Coney for their work in leading on the exhibition's complex installation; Hayward Registrar Imogen Winter and Assistant Registrar Charlotte Booth for skilfully overseeing the transport of works; Lucy Biddle for her innovative exhibition guide and website texts; and Hayward General Manager Sarah O'Reilly for expertly weighing in on multifarious organisational and budgeting issues. In addition, architect Nikolai Delvendahl deserves our thanks for his excellent work on several aspects of the exhibition, including the production and design of *Decision Corridors*.

As always, I am extremely grateful for the support and enthusiasm of Southbank Centre CEO Alan Bishop and Artistic Director Jude Kelly as well as Southbank Centre's Board of Trustees and Arts Council England.

Finally, our most profound thanks go to Carsten Höller for all his brilliant work as an artist over the past 25 years, for his generosity, and for his ceaseless desire, evident in all stages of our planning, to make this exhibition as engaging, thought-provoking and memorable as possible.

Ralph Rugoff
Director, Hayward Gallery

Dec**WITHDRAWN**

Books are to be returned on
the las

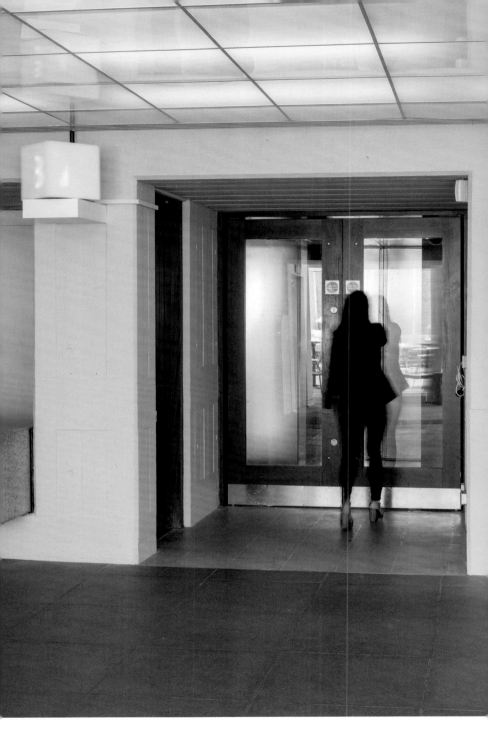

A B Sign, 2015. Photo: Elzbieta Bialkowska

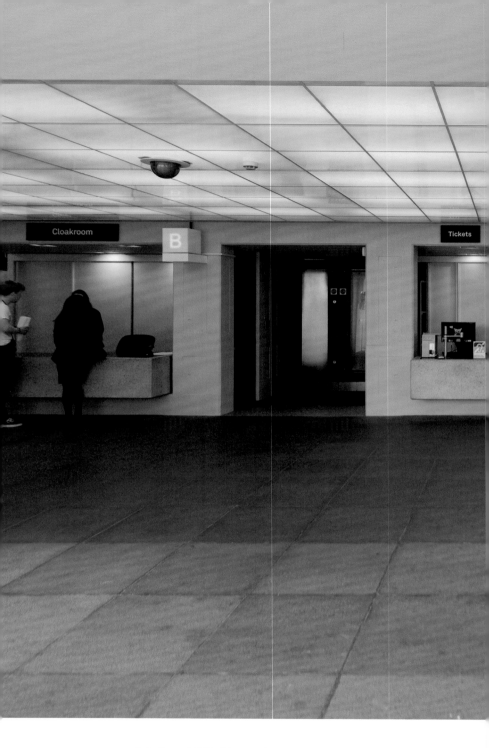

A B Sign, 2015. Photo: Attilio Maranzano

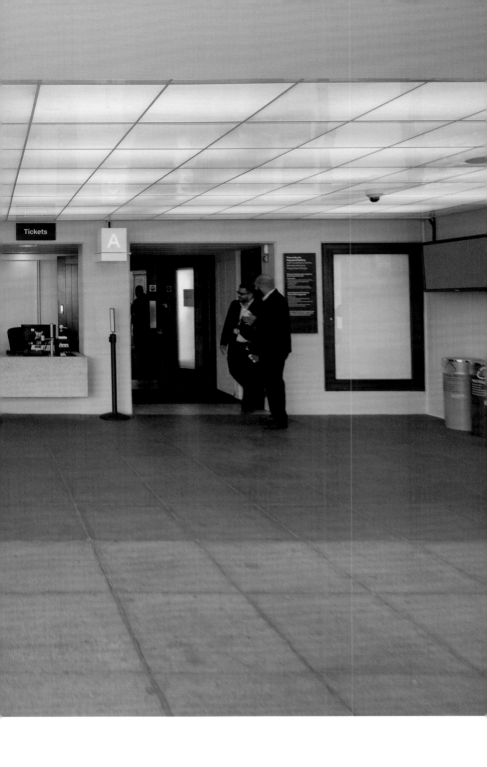

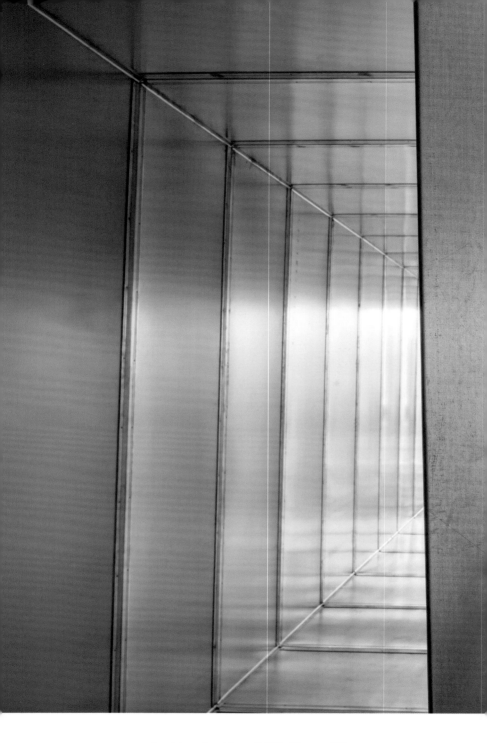

Decision Corridors, 2015. Photo: EB

Decision Corridors, 2015. Photo: AM

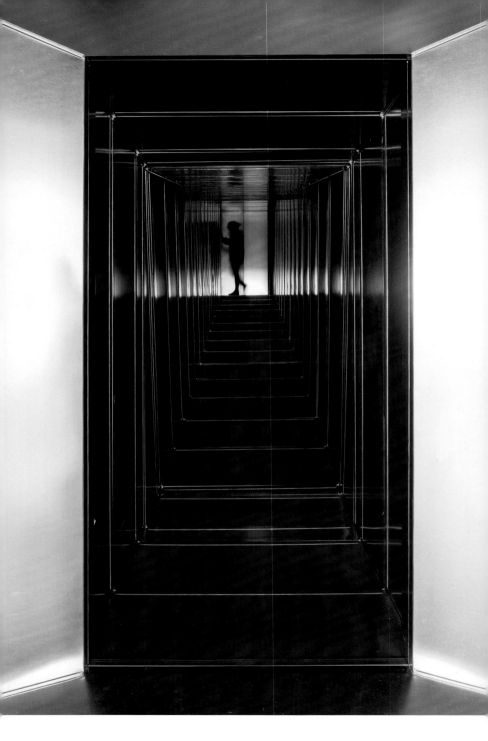

Decision Corridors, 2015. Photo: EB

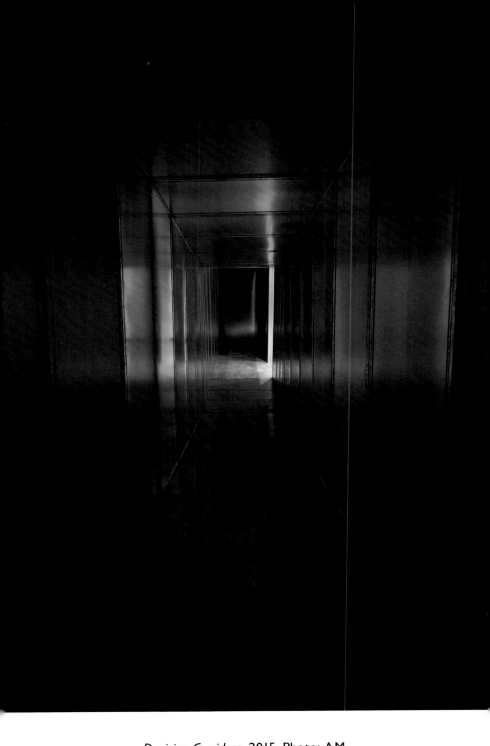

Decision Corridors, 2015. Photo: AM

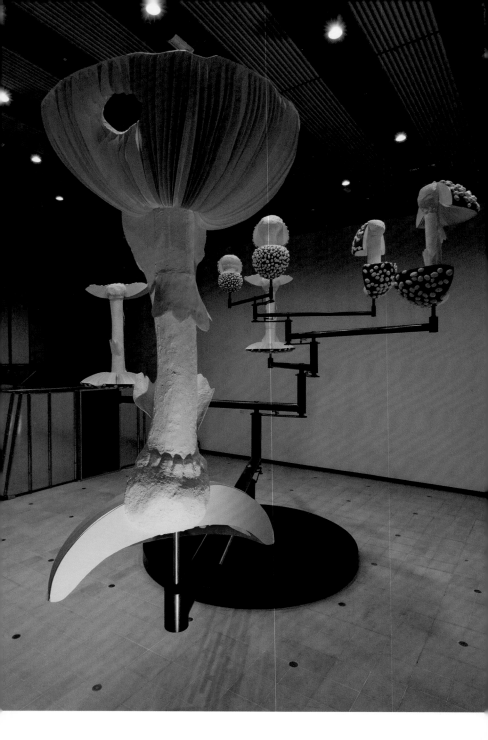

Flying Mushrooms, 2015. Photo: AM

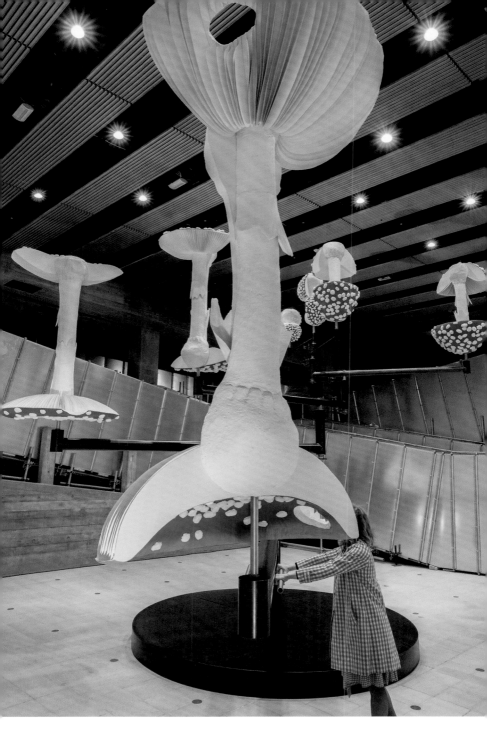

Flying Mushrooms, 2015. Photo: EB

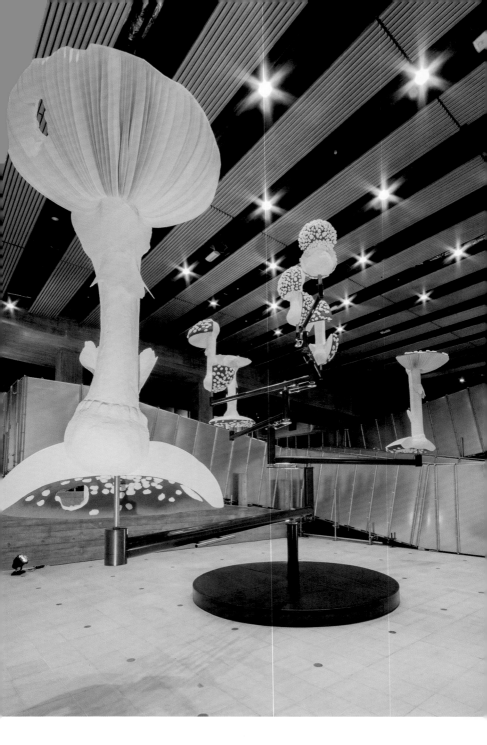

Flying Mushrooms, 2015. Photo: EB

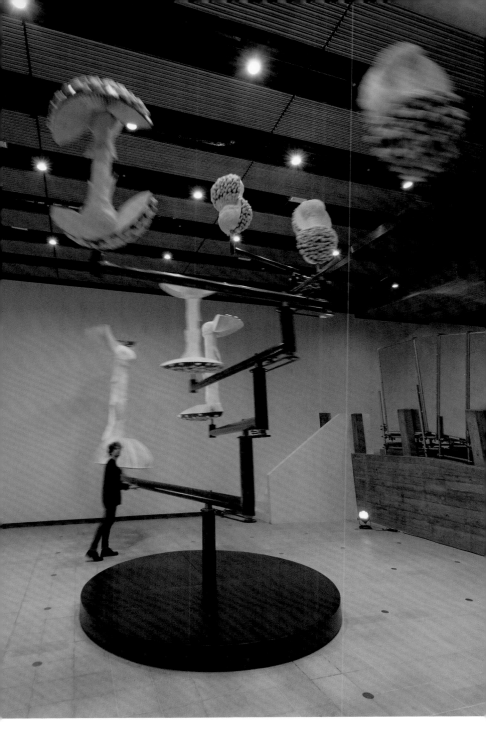

Flying Mushrooms, 2015. Photo: AM

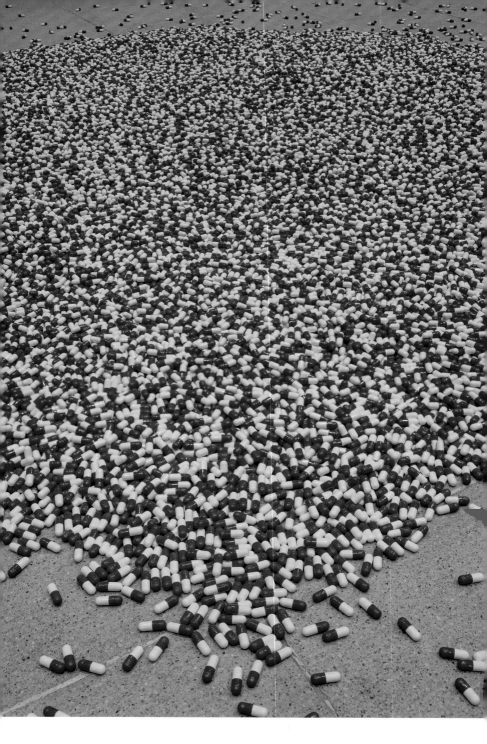

Pill Clock, 2011/15. Photo: AM

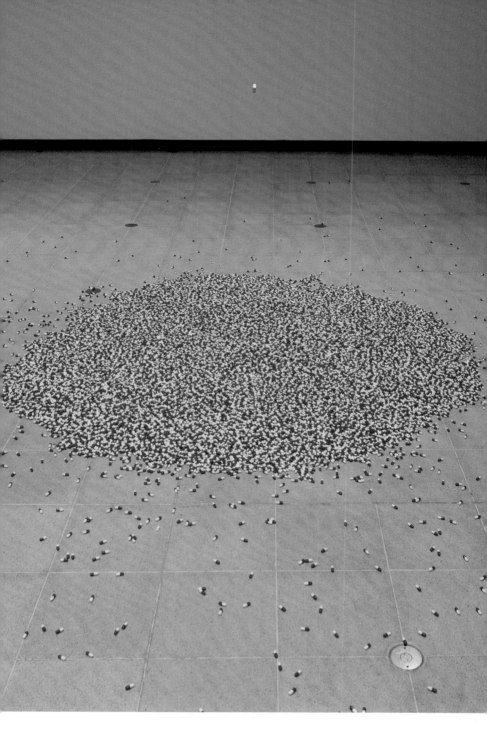

Pill Clock, 2011/15. Photo: EB

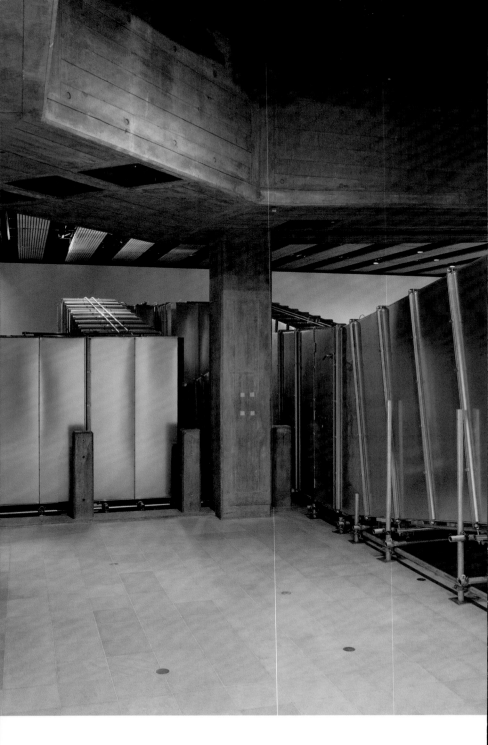

Decision Corridors, 2015. Photo: AM

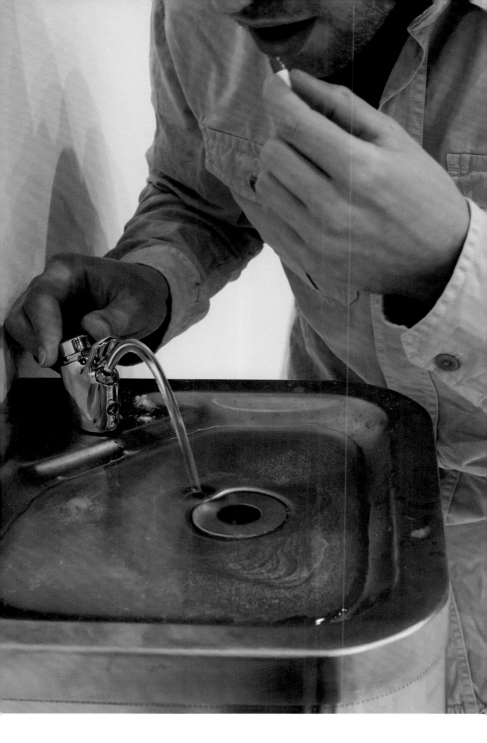

Pill Clock, 2011/15. Photo: EB

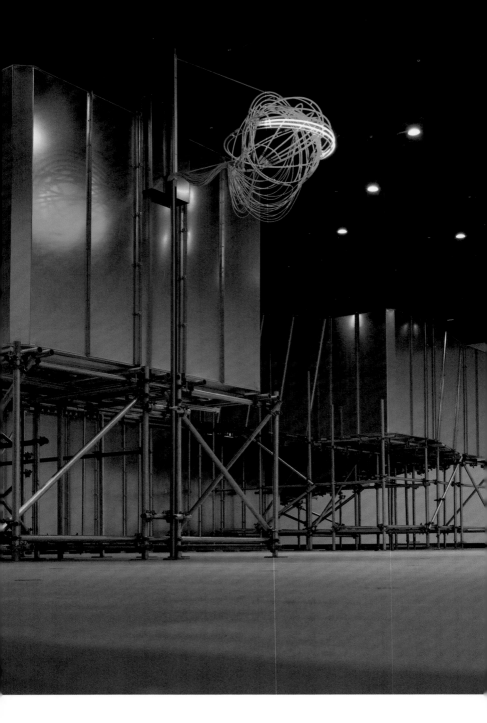

Half Clock, 2014. Photo: AM

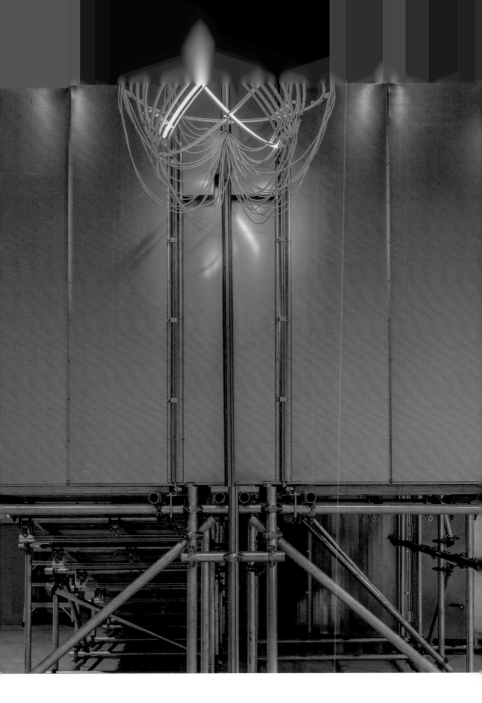

Half Clock, 2014. Photo: EB

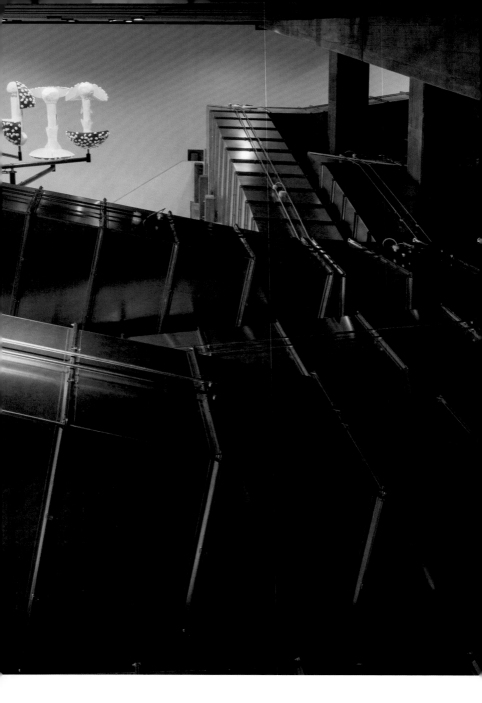

Decision Corridors, 2015. Photo: EB

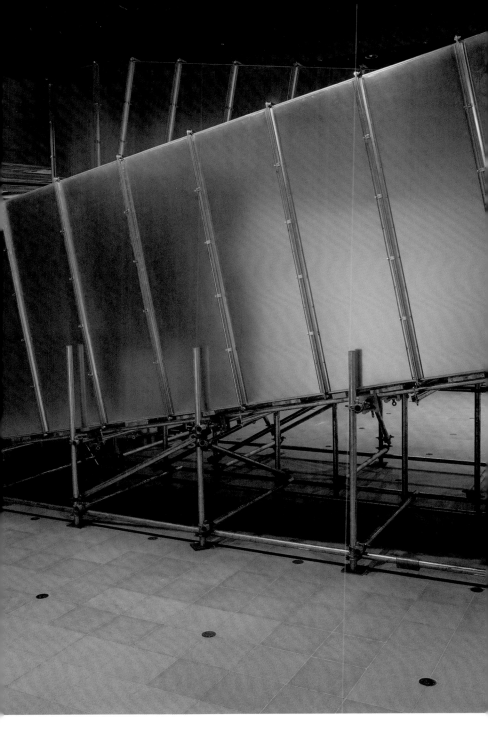

Decision Corridors, 2015. Photo: AM

Divisions (Wall Painting with Aphids), 2015. Photo: AM

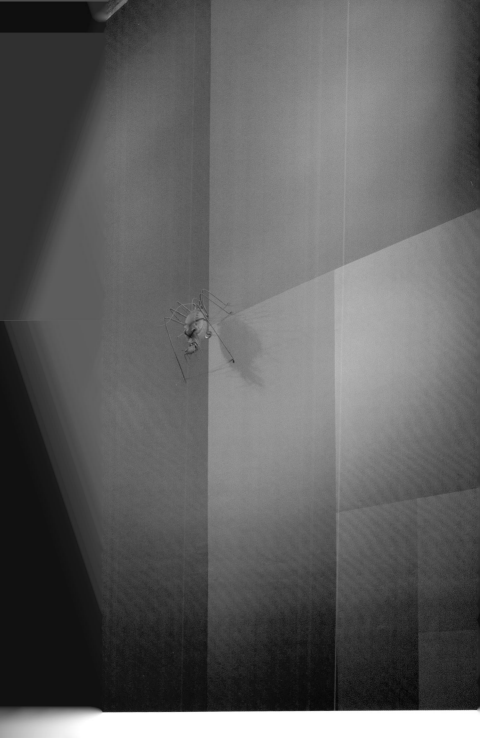

...isions (Wall Painting with Aphids), 2015. Photo: EB

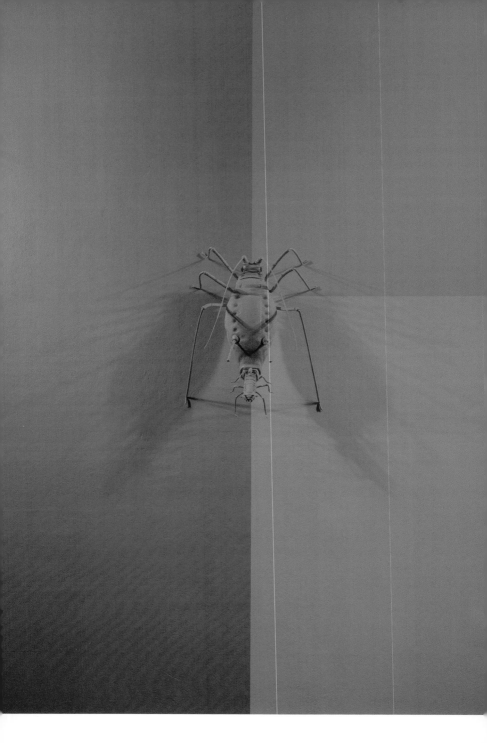

Divisions (Wall Painting with Aphids), 2015. Photo: EB

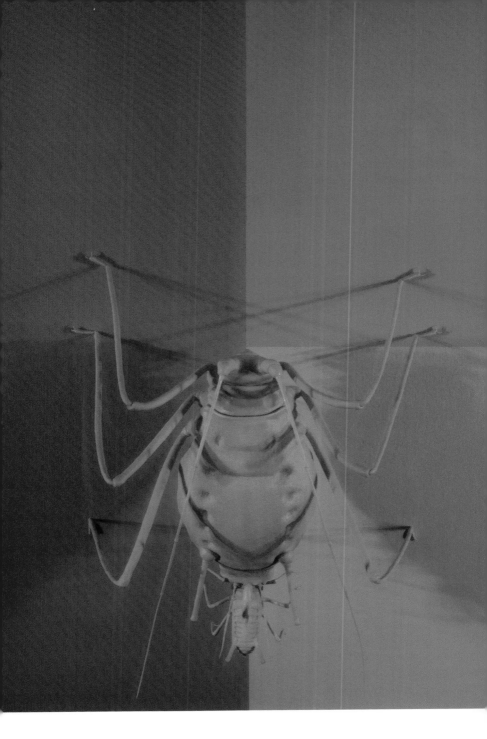

Divisions (Wall Painting with Aphids), 2015. Photo: AM

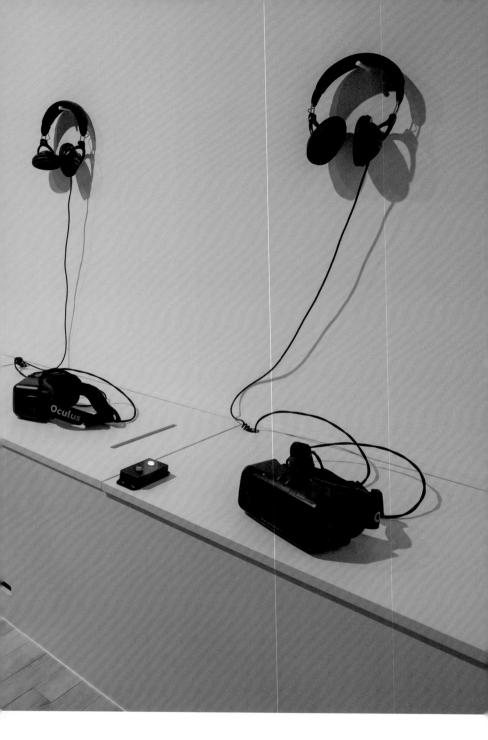

The Forests, 2002/15. Photo: AM

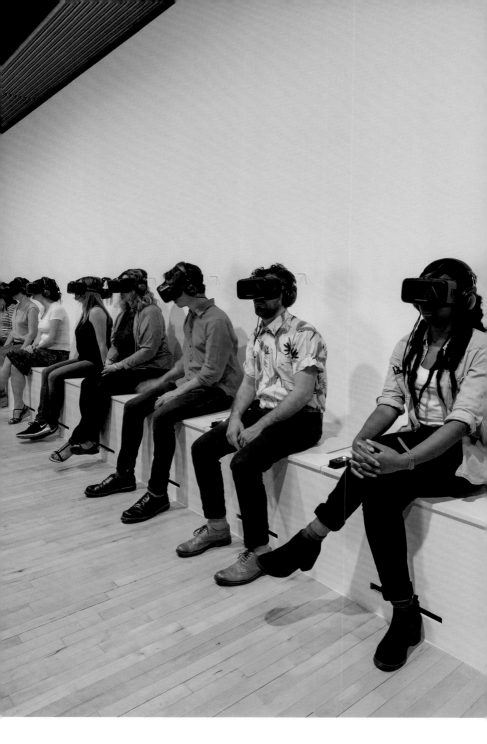

The Forests, 2002/15. Photo: EB

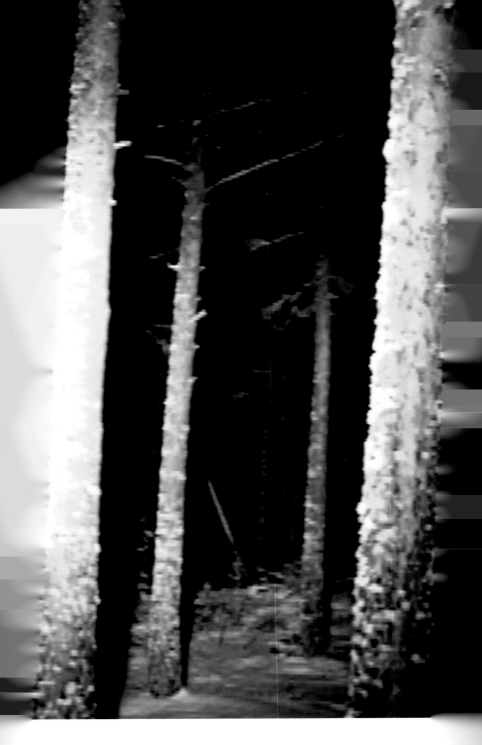

The Forests, 2002/15. Photo: CH

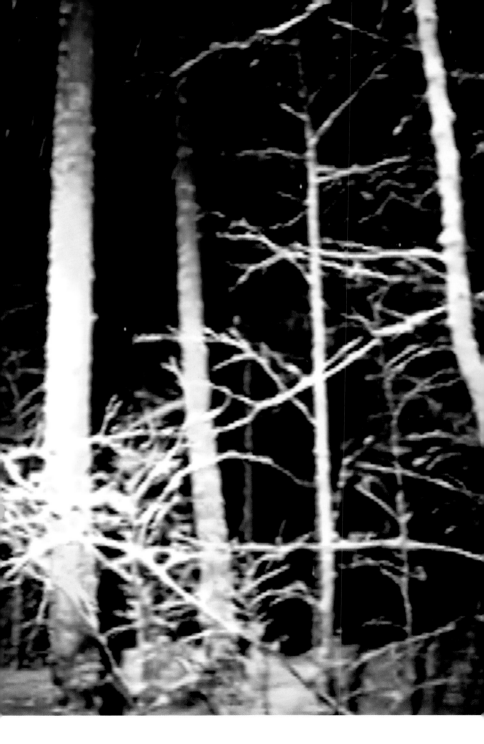

The Forests, 2002/15. Photo: CH

7,8 Hz (Reflective Concrete), 2015. Photo: AM

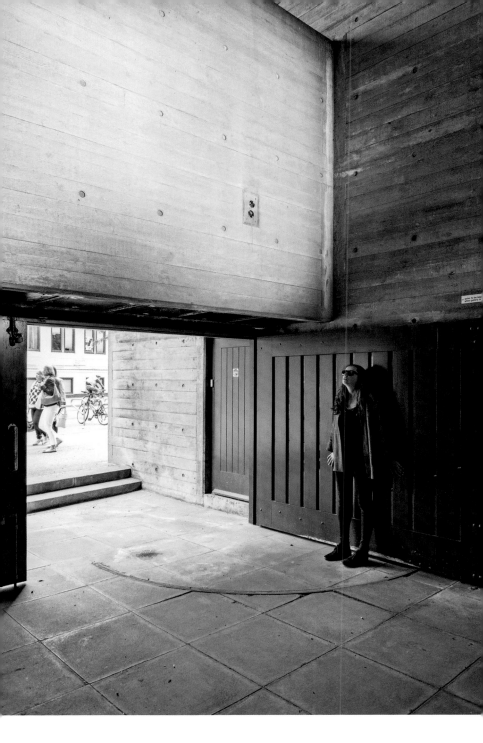

7,8 Hz (Reflective Concrete), 2015. Photo: EB

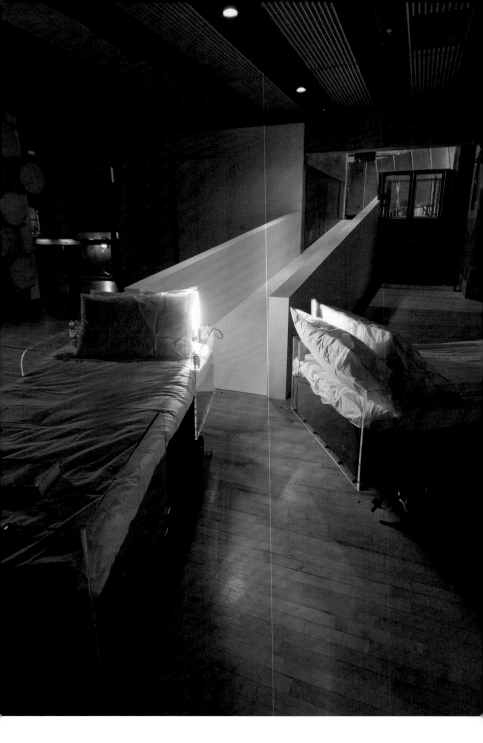

Two Roaming Beds (Grey), 2015. Photo: AM

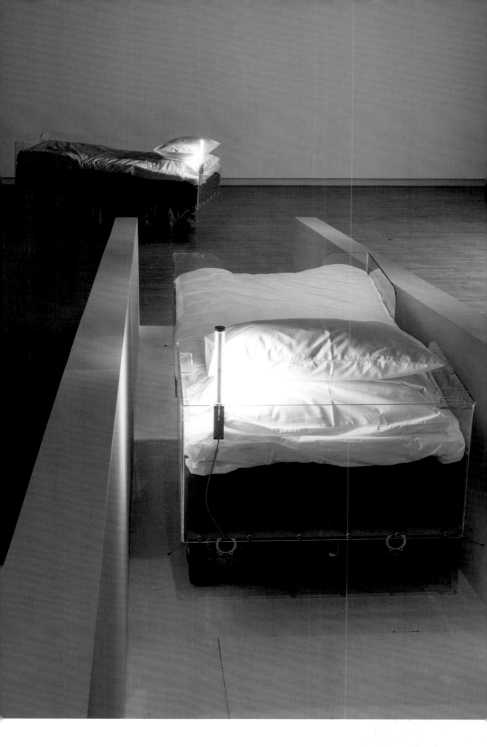

Two Roaming Beds (Grey), 2015. Photo: EB

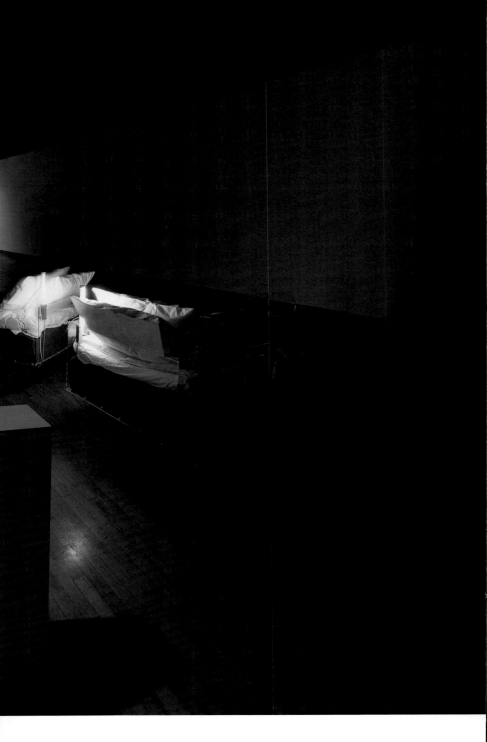

Two Roaming Beds (Grey), 2015. Photo: AM

Carsten Höller
in conversation
with Ralph Rugoff

Part One:
Punishment and Reward

Ralph Rugoff Your work is often associated with experiential installations and your last major museum show was titled *Experience*. But for your exhibition at the Hayward Gallery you have chosen the title *Decision*, which evokes thinking and mental processes. Can you tell me how you arrived at this particular decision?

Carsten Höller I've been interested for some time in the idea of doubt as a condition, as a human condition if you want. 'Decision' could be the next step. Its first association for many people is probably the decisions in their lives, big ones and small ones. These decisions make us, but we don't really know how we make the decisions. That's a complex matter. So I thought it could be good to frame the show with this title in order to create a platform for experiencing decision-making in an artistic context. At the same time we are also showing the decisions we made about what to include in the exhibition. So in a sense the title is being honest about this. And of course people who come to the Hayward will make a judgement about the exhibition. They will make a decision about how good or bad it is, or how it affects them, or what kind of experiences they are going to have in it. So I want to be honest about the visitors deciding too.

RR As visitors to an art gallery, we are always making small decisions: where to look, with what kind of perspective, and so on. In your exhibition visitors must begin by making a decision about how to actually enter the Hayward, as there are two separate entrances with signs marked 'A' and 'B'. But as soon as someone passes through either door the sign – somewhat mischievously – changes and displays the other letter.

CH This is a way of creating a situation where a visitor is already changing something simply by being present in the exhibition. It's underlining that your presence is appreciated but at the same time it is used, because you become part of the exhibition for the other visitors.

RR Each door leads to a different metal corridor that takes a twisting and unexpected route through the Hayward's first gallery. So from the beginning you've set up a kind of asymmetry in terms of how the public will experience your exhibition.

CH Yes, you might have the feeling that you're missing out on something because there's always another possibility, or there's another way to do it, or maybe there are many ways. But it could also be that

maybe there are two parallel shows happening at the same time. It's an idea I've been interested in for a long time. In any case, the presence of visitors has been included in the calculations for the show. When you are in the corridor, for instance, part of the experience will be the other people who are also there. The corridor is actually a way of doing something with their presence. You will not always be able to see the other people, as the corridors are very dark in places. Some people are in the other corridor, or not in the same section of your corridor, but you will hear them making sounds, thanks to the metal flooring and walls. Since, in places, the two corridors cross over and beneath one another, you sometimes hear others above or below you, and of course in front of and behind you.

RR When you enter *Decision Corridors* (2015) you can't really see where you're going because of its twisting layout and also because of the absence of illumination. In places it's so dark that you have added handrails so that visitors can feel their way along. It seems like you have chosen to deliberately frustrate our expectation of immediately seeing something when we enter a gallery.

CH Normally when I do exhibitions, I put a lot of effort into the first experiences you have. When you come into a large space, for instance, you see everything more or less in front of you. That's what I call the 'three seconds effect', when you make up your mind. You can still change it later, but with that first look your mind has already created a foundation for judgement. This time I'm hoping to delay that process with the corridors, in the sense that there's nothing to see, it just brings you somewhere else. The corridors will hopefully function like a lock for ships in a canal: a space where you go from one level to another, a situation where you make an adjustment.

RR The corridors seem designed to create an interesting psychological state, in which you're not exactly lost, but you still have no idea where you are going.

CH Yes. It's like when you go down into a cellar and there's no light, so you're feeling the steps with your feet. Bruce Nauman has said something about this. You know the steps are always the same but you don't know when they stop. You think you are already at the end, but there might be one more, so you feel this kind of insecurity. This moment of not knowing is an intriguing situation for me. With the

corridors, and with many of the works in this show, I'm trying to create a situation of not knowing in order to extrapolate from this uncertainty, so to speak, and also to bring out its beauty, its power, its wisdom even.

RR The writer Elias Canetti once said that the most frightening thing for humans is to be touched in the dark by an unknown hand. I imagine that many visitors will find the experience of being in *Decision Corridors* quite unsettling, not to mention claustrophobic.

CH It should be an unpleasant experience, so that you start off the exhibition with something that is a punishment, where you just hope it's over soon. Perhaps you're already thinking, 'Oh, why did I come here at all?' You will not enjoy this, but then maybe at the end of the show, when you're exiting the building down a slide, you might think that it's actually a very similar situation, except that the slide is curved and gives you a joyful experience. The beginning and the end of the show are done in the same way but produce very different results.

In the corridor made for the Hayward exhibition, there's one new little element that hopefully adds to the experience in yet another way. All the turns in both corridors are straight angles, but in the place where it's darkest there's a single curve in each. Taking vision away makes you feel things differently, and suddenly you encounter a curve, the only curve in the whole corridor, and maybe you aren't sure how much of a curve you really took because it's so dark in there. This will help to intensify the disorientation.

RR When people finally emerge from the corridors, they enter an open gallery space occupied by your *Flying Mushrooms* (2015), a sculpture which conjures up a much more playful kind of disorientation.

CH Since the corridor has been a punishment, you want to offer something nice as a reward. *Flying Mushrooms* is like a mobile, but instead of hanging from the ceiling it's standing on a rod on the floor. The horizontal bars and vertical bars that construct this mobile are sized according to a mathematical principle of division, just like the seven giant mushrooms in the sculpture are each divided into two. They're cut in the middle, longitudinally, and then put together again so that one half is upside down and the other half is upright. When visitors push the lowest horizontal bar of the sculpture, which is at the same height as the handle of a turnstile, the whole thing turns and all the different bars start to extend in different directions and the mushrooms

also start to spin like propellers. It's about making them fly really – they will dance around in space.

RR If no one activates the sculpture by pushing the lower bar around, the mushrooms do not really seem to be 'flying', do they?

CH That's right, but they're still up there in the air, and they still are impressive. It's amazing how much of an effect this particular mushroom has on people.

RR They are modelled after the *Amanita muscaria* mushroom, or fly agaric as it's also known, which has been appearing in your work for almost 20 years now. Why have you kept returning to this motif?

CH I find mushrooms appealing in many ways, because they're so powerful in terms of form, colour, taste and toxicity, and are so unnecessary. They're really a conundrum – we don't know why they are like they are. Usually evolution is adaptive, but I don't see any adaption there. Most mushrooms don't even attract insects to pollinate. So why do you have all these different colours and shapes? Also, why do you have all these different-tasting mushrooms? And of course some are hallucinogenic, like the fly agaric, some are just very bitter and some are lethal. Personally, I come from an evolutionary biology background – that's how I was trained to see the world – and I think evolutionary theory is a powerful explanatory model, but I'm always looking for faults in this theory. I would like to dispute its explanatory supremacy. I'm looking for things that don't fit. So for me the question of the mushroom is puzzling.

RR The *Amanita muscaria* also has a very striking appearance.

CH If you show a mushroom like this, it immediately attracts people's attention, but it's not simply because the fly agarics are flashing white and red. Humankind has a special relationship to the fly agaric which is not comparable to other mushrooms. It has probably influenced our culture. We don't know to what extent because we can't trace it back very far, and we are talking about pre-Christianisation here, but it's an attractive thought that it has affected our cultural development by opening up the possibility of looking at the world in a different way.

RR After encountering your *Flying Mushrooms*, visitors come to a large, almost empty gallery where a box in the ceiling (*Pill Clock*, 2011/15)

measures time by dropping gelatine capsules onto the floor every three seconds. There is a water fountain in the room in case visitors decide to ingest one of the pills. Coming as it does after a sculpture featuring giant *Amanita muscaria* mushrooms, many visitors might well wonder if the pills also contain some kind of perception-altering substance.

CH I don't want to be too explicit about this work, but there are a number of elements that I can talk about. First of all, the pills, which are red and white, have the same colours as the mushrooms, so they might suggest a synthesised version of the mushrooms' ingredients. Then there's the whole issue of going to art shows and not being allowed to touch things. Because over one million pills will drop onto the floor during the exhibition, you are inevitably going to step on some of them and think, 'Shit. I've just killed an artwork'. There will be white powder coming out of the capsules, some kind of placebo formulation, and you will have it under your shoes and you will spread it into the rest of the show, and maybe out into the city. I like this idea of contamination, of being without boundaries. At the same time, people can ingest the pills if they want to, and make them disappear that way. But they won't know what's in the capsules. Honestly, I don't even know myself.

RR I was wondering why you chose this particular interval of three seconds for the dropping of the pills.

CH It's quite fast, but then it's also long enough to allow for what has been described as being the feeling of presence.

RR So three seconds is the time needed to create the impression of an individual event separated by a past and a future?

CH Hopefully you have time to feel like 'I'm here and I'm looking at this pill clock'. This is just what is happening at this moment. Perhaps you wonder, 'Shall I take one or not?', 'What does it look like?', 'What beautiful colours!' Then the next one drops.

RR While the pills are dropping on the floor in the gallery, two robotic beds are slowly moving across the same space, tracing arc-like trajectories like a pair of restless insomniacs. How did this idea for *Two Roaming Beds (Grey)* (2015) develop?

CH It is in fact very comforting to sleep in something that's moving. You don't see many people sleeping in public spaces, but you always see people sleeping on buses, trains or airplanes. So in some ways it seems to be a natural state.

RR Because the beds are programmed to move in relationship to one another, they feel like a kind of couple.

CH Yes, essentially they mirror each other's movements, but one is always in command. That relationship changes, however, whenever the dominant bed encounters some kind of physical obstacle or hindrance in the gallery. At that point it begins to move in smaller circles to get away. Then the other bed might take command, as it were.

RR Despite the complex engineering involved, *Two Roaming Beds (Grey)* calls to mind something out of a dream or fairy tale – like enchanted beds that uncannily possess some kind of agency, or that have been put under a spell so they can never rest.

CH It's more about introducing a moment of uncertainty. You can't take it for granted anymore that the bed you're going to sleep in is going to be in the same place when you wake up.

RR As part of your exhibition at the Hayward, two people are sleeping in these beds each night. What do you think that experience must be like?

CH I want the beds to dance some kind of random ballet, so you as a sleeper are danced with. I imagine it's almost like sleepwalking, but without having to get out of bed. Hopefully it affects your dreams and probably induces a certain form of madness.

RR Before going to sleep in the *Two Roaming Beds (Grey)*, the Hayward's sleepover guests can also decide to try your special dream-enhancing toothpastes.

CH There are actually four different toothpastes that I developed with perfumer Ben Gorham. One is the 'Activator', and it makes you dream more and you also have a better memory of your dreams. Then we want to give the dreams directions, so you can choose between toothpastes designed for men, women and children. You can also mix

these different versions. It's a bit like the painter in Provence, sitting there with his palette and having different colours that he mixes in order to paint the landscape in front of him. Only here you will have differently coloured toothpastes that you can mix on your toothbrush, and then you're painting the painting in your head by brushing your teeth. The dream is your painting. It gives you the possibility to produce an artwork.

RR Another work in the show that has a decidedly oneiric character is *The Forests* (2002/15), a dual-screen video that visitors watch with a 3D video headset. The video begins with a slow tracking shot of snow falling gently in a forest at night. It's a dreamy picture that lulls you into a state of relaxation, and then suddenly there's an experience that is like having your vision split in two, as the images on the tiny eye monitors suddenly diverge in different directions.

CH This film was shot with two cameras that were tracking side-by-side on rails, so they produce a 3D image, and then when they come to a certain tree one camera goes to the right side and the other to the left. Later for a short moment the two cameras line up again to produce a single image, but it lasts for less than a second, so you're not even sure what you're seeing before it breaks up again. I think one of the most rewarding things about this work is to understand how long it takes before you start to see different things with your two eyes. You can almost feel how the brain is getting stretched like a chewing gum as it tries to hold onto the perception of a single image. You already know these are two different images that you are looking at, but the conservative mechanics in the brain still treat it as one.

RR It becomes an almost hallucinatory experience at that point.

CH Yes, it's not very pleasant really, but it's definitely strong.

RR Neurologists say that it's actually impossible for us to hold two different images in our mind at the same time, which is what *The Forests* seemingly asks us to do.

CH There is always more than one image in our visual field if both eyes are open and functioning, but there's always only one that we see. With *The Forests* I was trying to break that hierarchy, or even dictatorship if you want to call it that, of the single image. I wanted to see if you could do with your eyes what you do perfectly well with your ears.

We experience stereo sound all the time, we use it in music and it helps us to orientate ourselves. So how can we use these instruments, our two eyes, to enable some kind of double vision? The first work I made exploring this was very simple, but it produced a stunning effect. It was a pair of sunglasses that was part of a kit called *Expedition for the Exploration of the Self* (1995). Each lens is a different colour, so you would still see the same image but one eye would be looking through a green lens and one through a yellow lens, for instance. What is remarkable is that it takes only a second and then you see both colours with both eyes.

RR How did you come up with that idea?

CH Out of frustration. I found it unsatisfactory to only see a single dominant image and I wanted to see something different with each of my eyes.

RR *Fara Fara* (2014), a two-screen video installation that is constructed around the music scene in Kinshasa, also challenges viewers to look at images in a different way. But before getting into that, can you tell me what the title *Fara Fara* refers to?

CH It means 'face to face' in Lingala, and it refers to a tradition in the Congo of holding musical competitions between two performers. Apparently, in former times, even in pre-colonial times, disputes over land would be settled with these competitions. Nowadays, these *fara faras* happen very rarely, but when they do happen they are an absolutely major event. It's organised such that the performers who play longest are the winners.

RR So it's like a marathon?

CH More like a mass phenomenon where you support the band, and if your support wanes the band stops playing and the other band that still has the crowd's support wins.

RR Is the *fara fara* chronicled in your installation a fictional version?

CH It's a construction. I did this project together with film director Måns Månsson. We used existing footage of concerts, and then we worked with a small crew to film some of the major musicians that we

are in contact with in Kinshasa. We edited all this material together so that it would work as a kind of announcement while also suggesting a documentation of a *fara fara*.

RR There is a narrator figure in the video, a third singer who performs what is almost like a ballad describing this epic face-off between these two great music stars who are competing with one another.

CH Yes, but the subtitles that translate Papa Wemba's song are really an invented text. Those who understand Lingala will know that he is singing about something completely different from what the subtitles say. This is an artistic freedom that I was happy to take. So you shouldn't take it literally, you shouldn't just believe the subtitles. It's a double-film, so to speak. It tells one story to those who are reading the subtitles, but for people who understand Lingala, it is a different story, a bit like Woody Allen's *What's Up, Tiger Lily?* from 1966, which is a film I like a lot.

RR For the video installation you've set up the two screens on opposite sides of the space, so the viewer is constantly having to make a decision about which screen to look at.

CH On one level it's a way of making your head turn right and left and creating a situation where your eyes must follow the sound because you hear it coming from either this side or that side, and then you're turning your head accordingly. It makes you experience how you look at film, because you constantly have to turn your head. It's also a bit of a joke that people are looking at this material and continually shaking their heads. For us so-called Westerners, the Democratic Republic of Congo has such an incredibly bad reputation. Of course it is torn by war and the worst atrocities have occurred there, but we cannot just think that this is a land in free-fall and that everything there is dark and dangerous. The war is in a certain part of the country, it's on the eastern border only, and Kinshasa is more than 3,000 miles away from this area. So from our occidental point of view, if you want to call it that, we think we know what is going on there but we have absolutely no idea. We just make it worse with this attitude, because we are passively promoting the war by selectively spreading information about the DRC that reinforces our negative view of this country.

RR How did you become interested in the Kinshasa music scene?

CH In 1995, I happened to hear a song in a discotheque in Benin. It really struck me and I found out it was by a star of Congolese music named Koffi Olomidé. Then I heard some more Congolese music and I just thought, 'This is incredible. I've never heard anything like this before.' These musicians have a very peculiar idea of constructing a song, and it really just speaks to me.

RR What is it about the construction of Congolese songs that so appeals to you?

CH A Congolese song often starts with an introduction that gives you a completely wrong idea of what the song might be about. This can be followed by another introduction that is also wrong, and even a third one, but it strangely all fits together. There are famous songs that start off as a series of ballads for half of the song, and then suddenly it becomes dance music, and at the end it regularly turns into what is called a *sebene*, which is when there is a lot of improvisation going on. It becomes very dense and danceable, but it's tricky music; it's not based on repetition and predictability like 'Western' music. It's more about a kind of meandering between different possibilities and also about surprising turns. In a way you can compare a good Congolese song to what I think a good art exhibition should be like. At least, I find a strong analogy in Congolese music to my way of working. So to put them together makes a lot of sense for me.

RR It seems that one aspect of your artistic approach is to have no signature style, because you realise ideas in many different forms and media. But at the same time you have certain signature gestures: your works often involve inverting things, mirroring and doubling, spinning and rotating. There is also a principle of division, of repeatedly dividing things in half, that characterises several works in *Decision*. For instance, *Divisions (Wall Painting with Aphids)* (2015) is composed by creating a large square on the wall, in a pigment we could call 'fly agaric red', and then adding sections where both the amount of pigment and the surface area is progressively reduced by half, until the painting covers the entire wall.

CH It's similar to the mathematical idea of the asymptote. It's a kind of equation that produces a curve that is tending towards a line, for instance, but never actually reaches it except in infinity. But it's getting closer and closer. This approach of making a division, and then a division of the division and so on, is the simplest form of getting into this asymptotical logic.

RR Inasmuch as it conjures a potentially infinite and immeasurable landscape, it seems to evoke the idea of the sublime, but without the usual romantic overtones.

CH It's more like a mathematical sublime.

RR As part of *Divisions (Wall Painting with Aphids)* at the Hayward, you have also included a new element: a sculpture of an aphid that has an intermediate colour and which is installed in front of the painting, in its exact middle. The aphid is represented in the act of reproducing itself, so it clearly relates to the idea of division.

CH Aphids generally have a non-sexual mode of reproduction, so it's a sculpture of a female giving birth to her own twin. She's making a copy or a clone of herself. It's a mechanistic principle in life that I think we also share in many ways, but we do the copying in a more mental way. My interest in aphids dates back to when I worked in agricultural entomology at the university, and we were rearing billions of them for our experiments. They're fascinating animals, and I always wondered, 'What would you think about an aphid that was as big as a dog?' This aphid in the show is that size.

RR *Half Clock* (2014) is another work in the exhibition that is structured by a principle of division. It seems designed, somewhat perversely, to be a clock that is almost impossible to read.

CH You can read the seconds quite easily, but it becomes more complicated with the minutes and hours. It definitely makes it difficult to see what time it is, as it shows only half the time, but it's still counting something. Basically the clock is constructed not as a disc but as three interlinking hemispheres composed of different curved neon tubes. One hemisphere is for measuring seconds, one is for minutes, and one is for hours. So a certain surface of the sphere is representing a certain amount of time. Then we divide it again and we come to quarters, and then eighths and sixteenths and so on. That's what *Half Clock* is based on, similar to the other 'Divisions' works. You understand this is a completely different way of measuring time. I wanted to make the most complicated clock on earth, but I think it works quite well if you get used to it and think of time as surface.

RR In the upstairs galleries in the Hayward, your *Half Mirror Room* (2008) adds yet another way of developing this principle of division, but in this case through replication. Two adjacent walls are mirrored from floor to ceiling, and they create an illusory double of this very large gallery space.

CH Yes, but this work is also about creating a mirror image that is the opposite of a plain mirror image.

RR Because each mirror reflects the other, reversing the usual inversion of a mirror image?

CH Yes, so it's a doubly wrong image, which means it's right again. And it is also a way to have this huge space multiplied by two.

RR Do you think that people might experience a kind of vertigo when they encounter this multiplied space?

CH It's more like a meditative experience. Many of the works in the upstairs gallery have a quieter tone. There's less colour, and it's almost like getting things back to a certain calm level before you step into the slides and exit the building. It's crucial for me to work with these two contrasting levels in order to offer different angles on the same problem of decision-making.
 I think it's a profound experience to stand in front of really big mirrors. It's overwhelming, because it shows you everything around you, and yourself in the middle of it. It's not about just you and the mirror, it's about you and the space.

RR Mirrors are often associated with the general realm of the uncanny. There is something about doubling that seems to unsettle our faith in the singularity of identity.

CH I'm more interested in what you call in German *das Unerschlossene*. In English it would mean the 'unexploited' or 'untapped', something that we cannot yet unlock or comprehend with our current set of tools, but we have some idea or evidence that it's there. And I think the mirror image is referring to one of the great enigmas of our time – the idea that one has of one's self. Personality has no explanation in science, not even in psychology or philosophy really. There have been a lot of attempts, of course, but no satisfactory results.

Mainly what I find so compelling is that you can't see yourself as other people see you. We seem to be unable to understand our own personalities, whereas other people have absolutely no problem understanding them. At the end of the day personality makes you the unique person that you are, but you can't see it. I'm interested in this blocking mechanism, or whatever it is, which prohibits you from seeing it. Obviously it's inbuilt that you shouldn't see it; otherwise you would maybe become a crazy person. So in this way, to look in a mirror, especially a big mirror, is a scary thing to do. You know you're there, but you just don't know who is really there. You are to yourself a perfect example of *Unerschlossenheit*.

RR And of course you are probably not looking at yourself alone.

CH Right. You're in a room where you're looking at a mirror image of yourself together with other people who are doing the same thing. As I said before, I want to include all the visitors in the show. You are not alone in the mirror room and you probably don't want to be, because maybe that's too much. To see others struggling with the same thing is comforting.

RR The idea of the double shows up again in the installation of your *Twins (Belgian, London, New York, Paris, Santiago de Chile, Tokyo, Vienna)* (2005–15) videos, which you have produced with identical twins in different cities over the past decade. Displayed on monitors that face one another, the twins make statements to each another in a strange, almost mirror-like manner.

CH It's an attempt to leave logic with the help of logic. One twin is saying, 'I always say the same as what you say', and then the other responds by saying, 'I always say the opposite of what you say', and then the first one, who always says the same thing, now also says 'I always say the opposite of what you say', which the second one, who always says the opposite, now answers by saying 'I always say the same as what you say'. And then the cycle repeats.

RR That's a really diabolical logic, a closed circle that spins endlessly.

CH But it all depends on which twin you hear first. Because if you hear the second twin first – the one who always says the opposite – then it sounds like the other one is simply repeating her statements.

And then it works like a kind of mantra; it has a hypnotic effect. But if you hear the twin first who always says the same, then both twins are in a dilemma situation because she says the opposite while still saying the same thing, or the same thing while saying in the statement before and after that she is saying the opposite.

RR Do you think the uniqueness of individual experience is greatly overrated? Is that partly why you're interested in doubles?

CH No, in a way it's all we have. And I think we can't possibly understand how it feels to have another copy of ourselves in the world, like identical twins and aphids do.

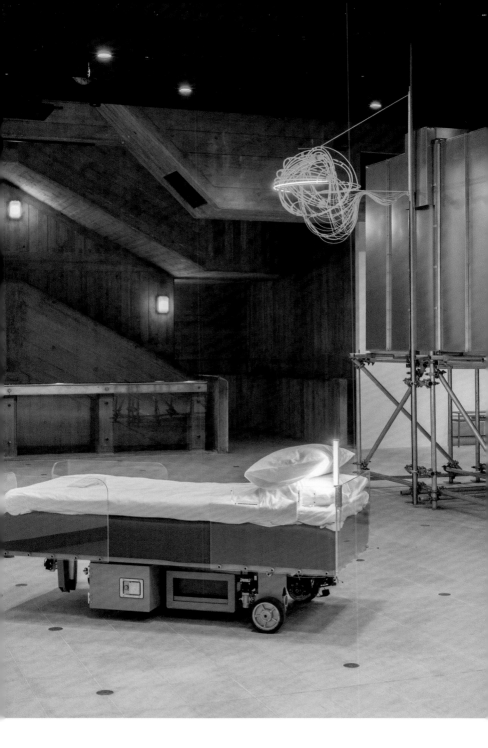

Two Roaming Beds (Grey), 2015. Photo: EB

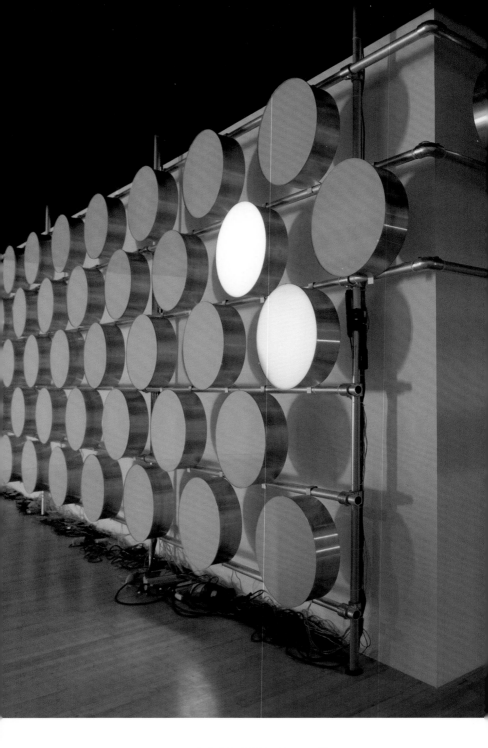

Phi Wall II, 2002. Photo: EB

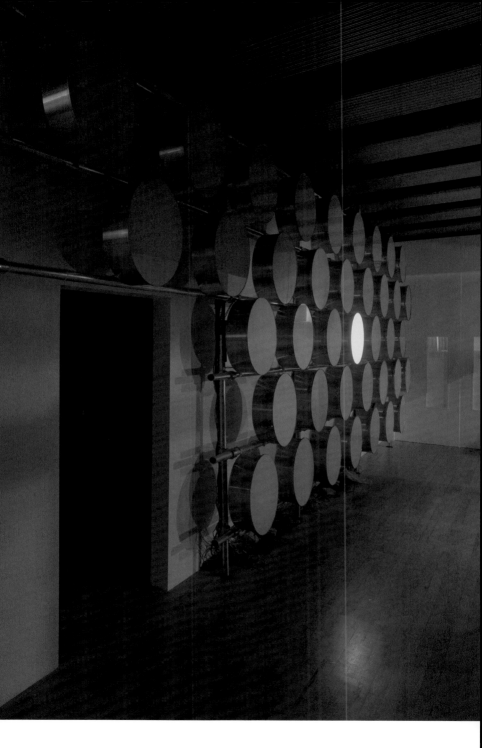

Phi Wall II, 2002. Photo: AM

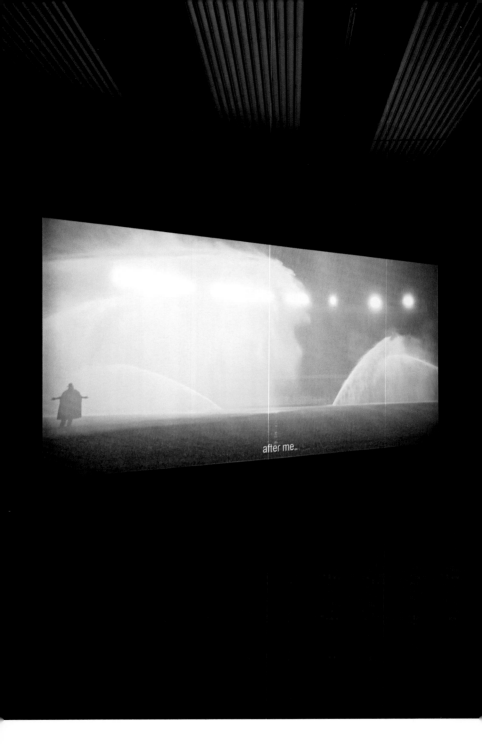

Fara Fara, 2014. Photo: AM

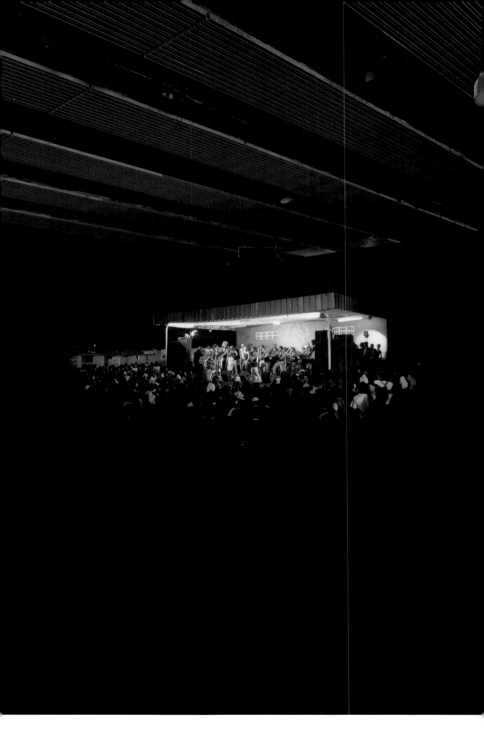

Fara Fara, 2014. Photo: EB

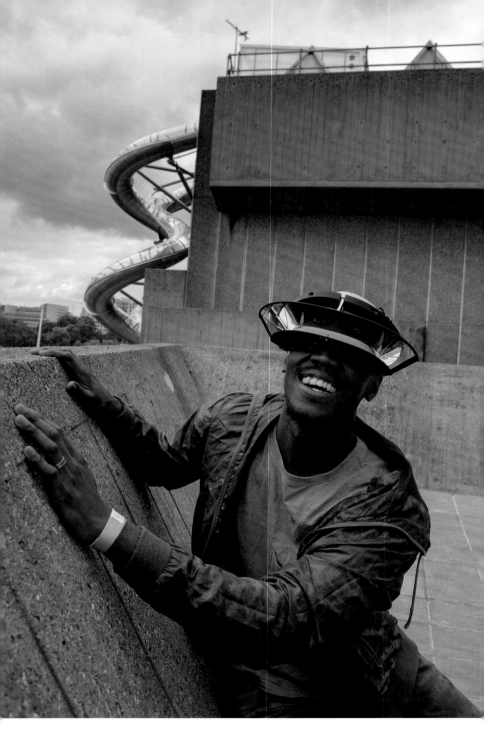

Upside Down Goggles, 1994/2009. Photo: AM

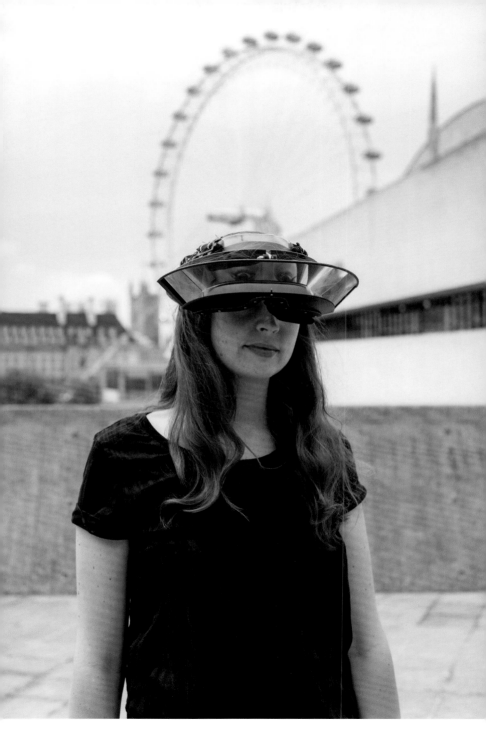

Upside Down Goggles, 1994/2009. Photo: EB

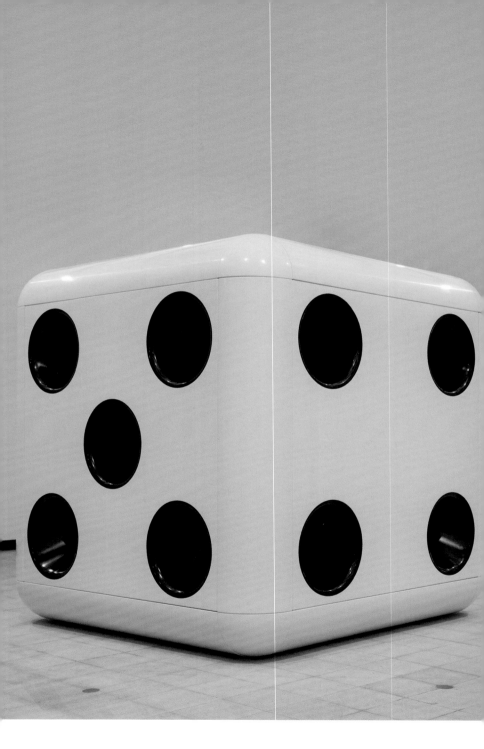

Dice (White Body, Black Dots), 2014. Photo: AM

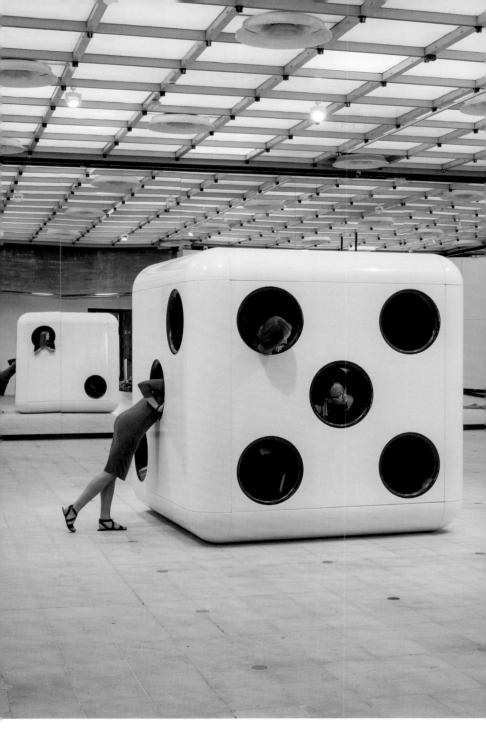

Dice (White Body, Black Dots), 2014. Photo: EB

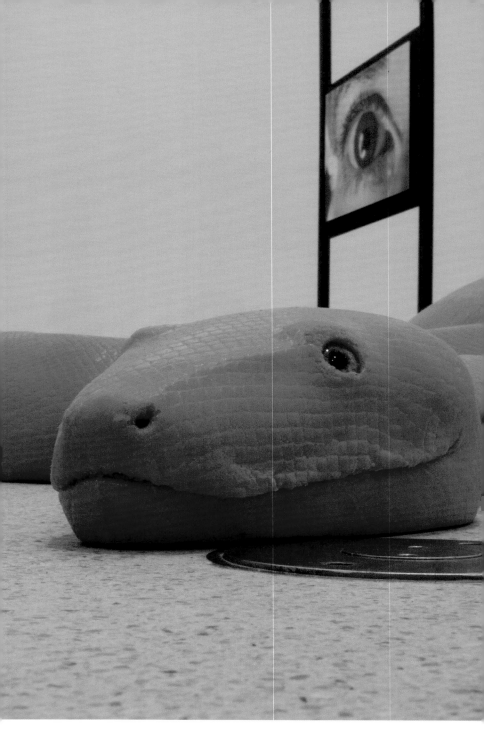

Snake, 2014. Photo: AM

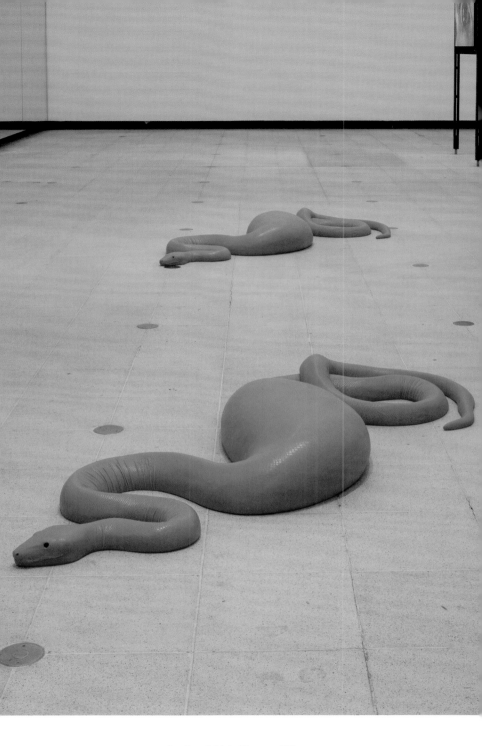

Snake, 2014. Photo: EB

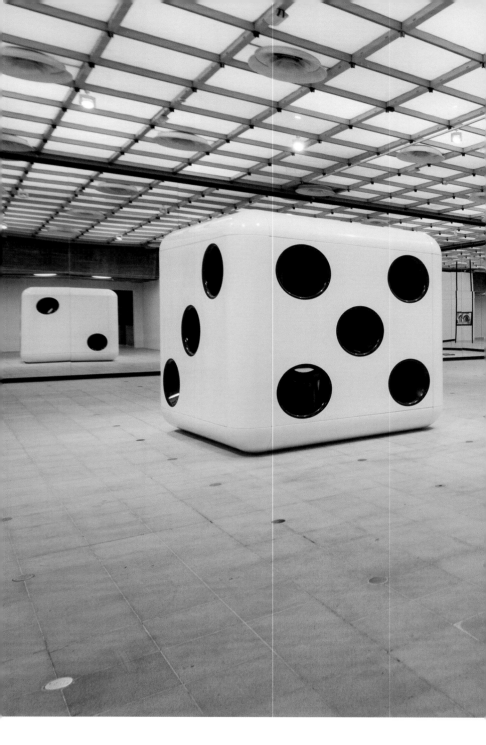

Half Mirror Room, 2008/15. Photo: AM

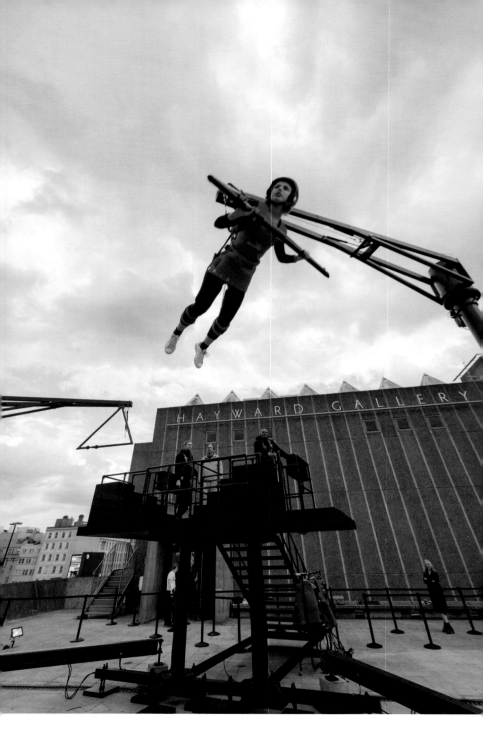

Two Flying Machines, 2015. Photo: AM

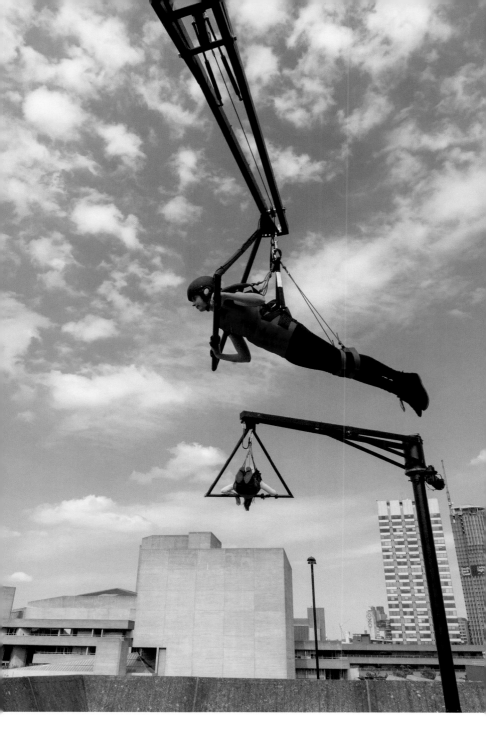

Two Flying Machines, 2015. Photo: EB

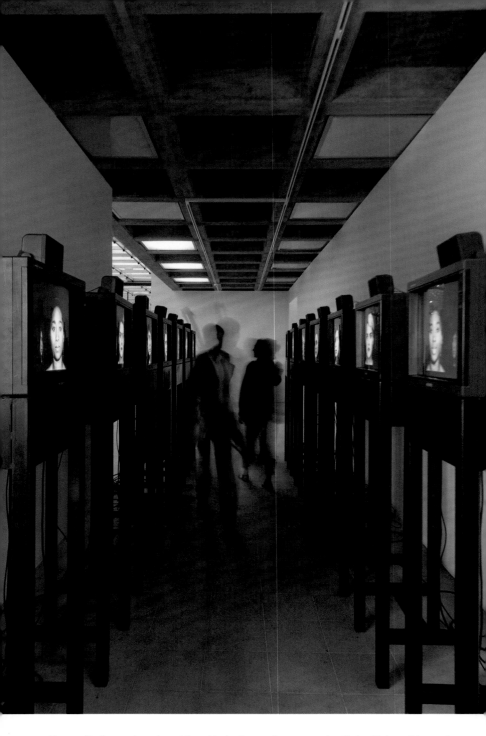

Twins (Belgian, London, New York, Paris, Santiago de Chile, Tokyo, Vienna),
2005–15. Photo: AM

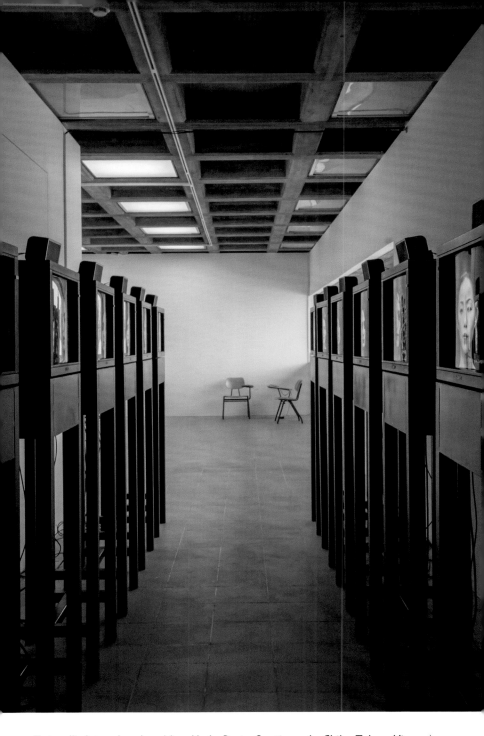

Twins (Belgian, London, New York, Paris, Santiago de Chile, Tokyo, Vienna),
2005–15. Photo: EB

The Pinocchio Effect, 1994. Photo: AM

The Pinocchio Effect, 1994. Photo: EB

Phi TV, 2007. Photo: AM

Phi TV, 2007. Photo: EB

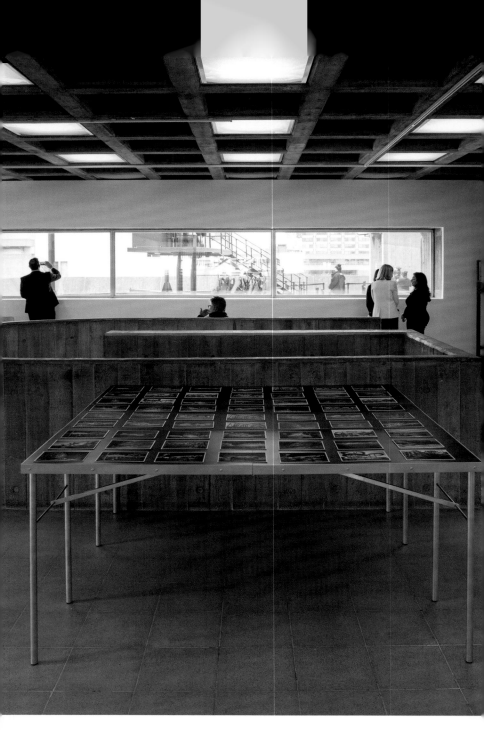

Memory Game and Table, 2013. Photo: AM

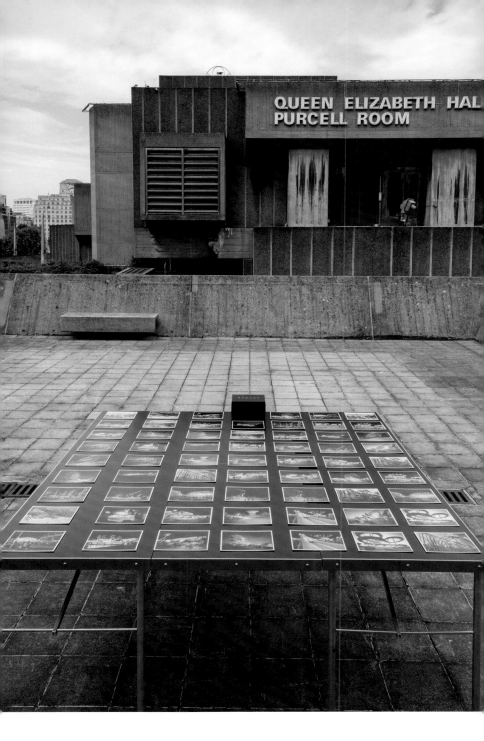

Memory Game and Table, 2013. Photo: EB

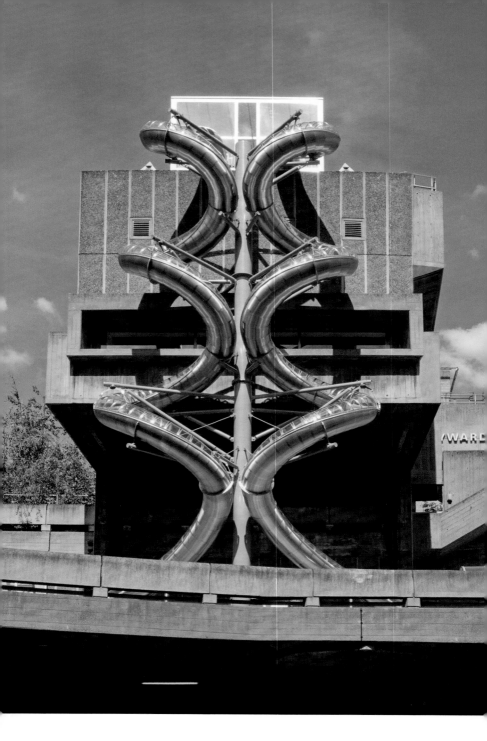

Isomeric Slides, 2015. Photo: AM

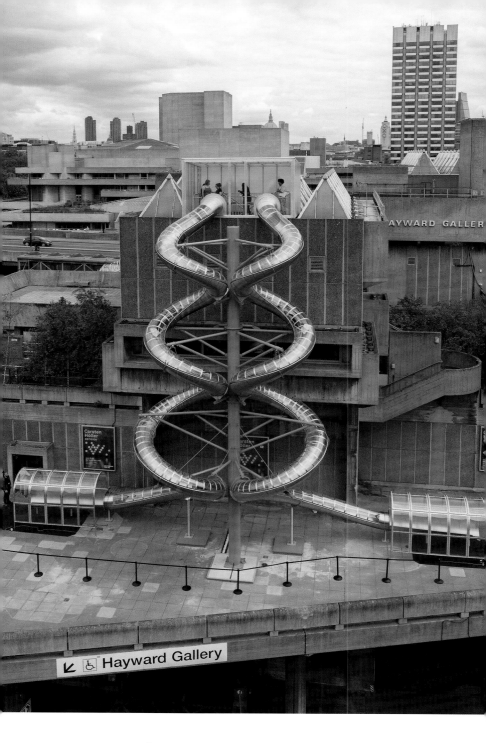

Isomeric Slides, 2015. Photo: EB

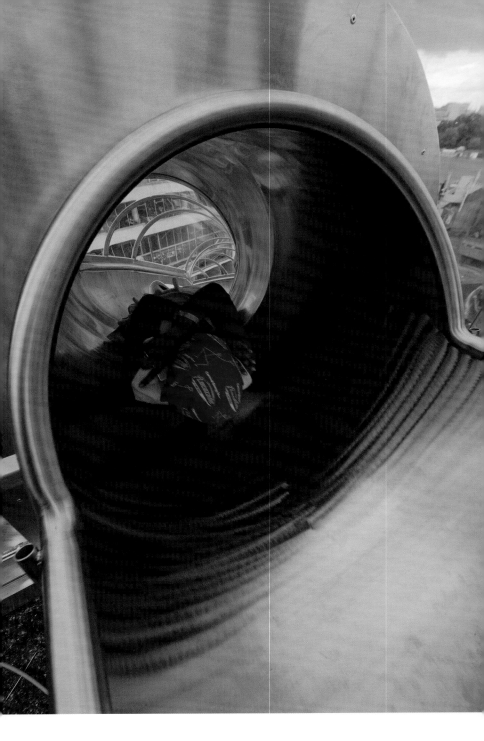

Isomeric Slides, 2015. Photo: AM

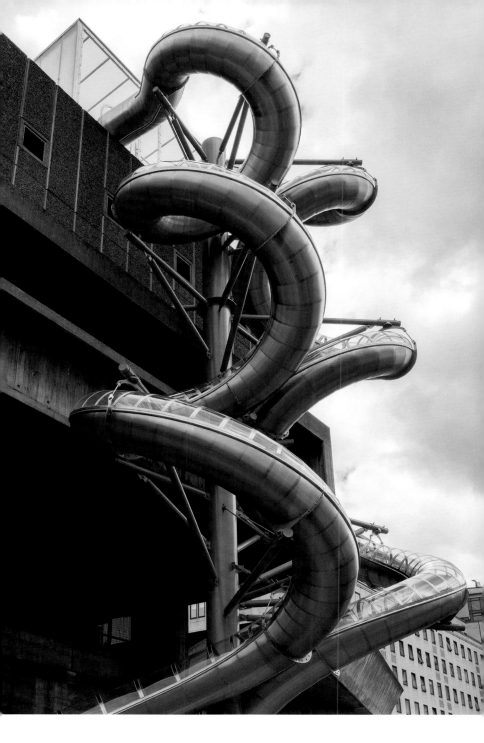

Isomeric Slides, 2015. Photo: EB

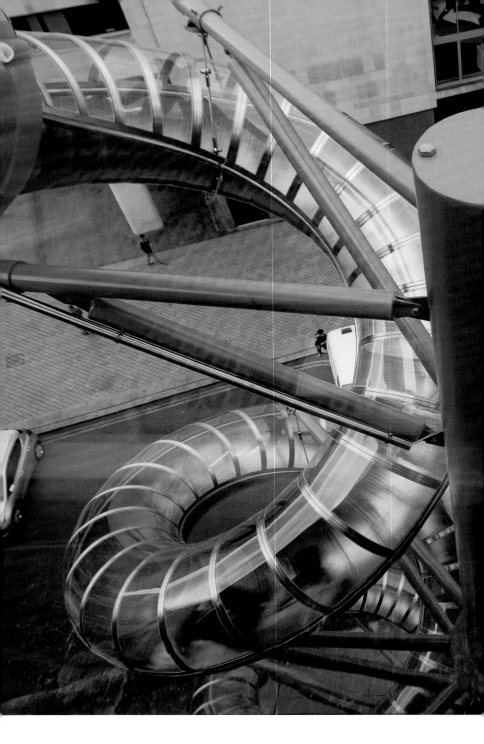

Isomeric Slides, 2015. Photo: AM

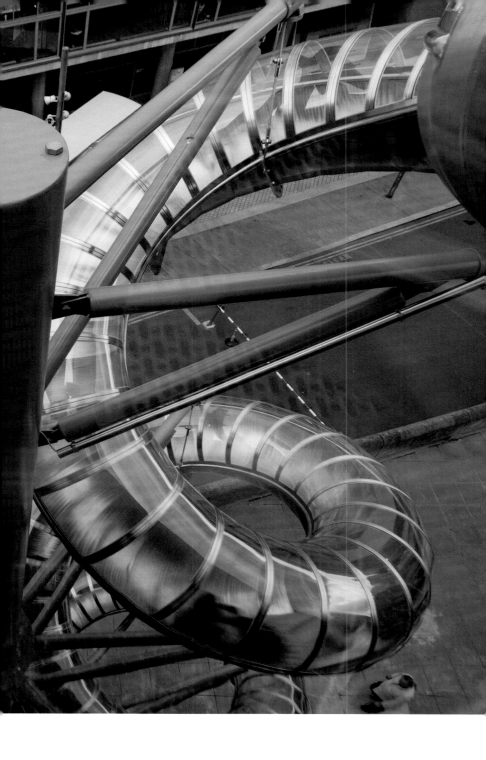

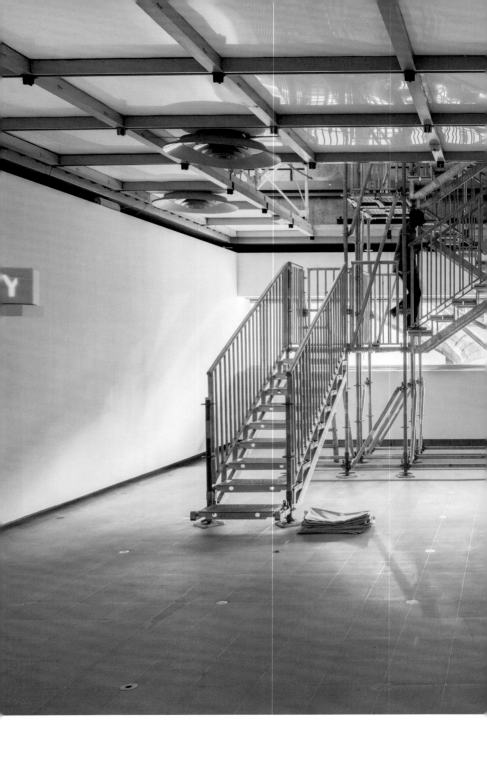

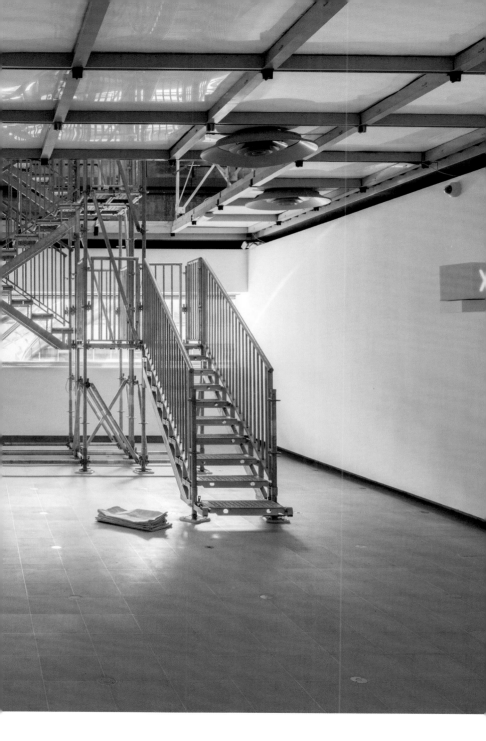

X Y Sign, 2015. Photo: EB

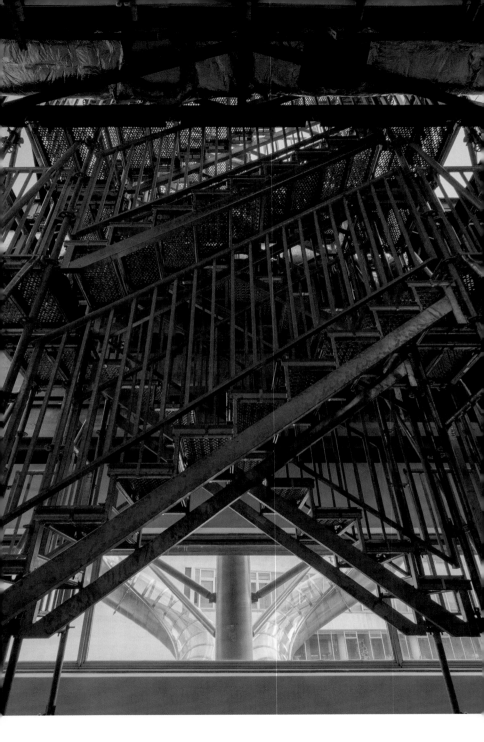

Isomeric Slides, 2015. Photo: AM

Carsten Höller
in conversation
with Ralph Rugoff

Part Two:
Spiritual Luxury

RR A number of works in *Decision* are devices that alter some aspect of our perception. Perhaps the simplest, but also the most radically destabilising, is *Upside Down Goggles* (1994/2009). You've said that they were inspired by a late-nineteenth-century experiment conducted by an American psychologist named George M. Stratton, who was exploring perceptual adaption.

CH In the mid-1990s I came across his accounts of his experiments. He conducted one experiment where he wore an inverting lens over his eye for three days and another that lasted for eight days. His account, which is written in a surprisingly eloquent style, describes how he eventually reached an intermediate state of not knowing anymore if something was upright or upside down. For instance, he had a candle on a table that was not lit and that he could see as upside down, but then after lighting it, he would see the candle as upright even though he still perceived the table as upside down. He gradually began to lose his certainty about how things stood. The *Upside Down People* (2007/09) I have worked with who have worn *Upside Down Goggles* for eight to twelve days have reported similar experiences. Some even had flashbacks in the days and weeks after they took off the goggles, where they might be sitting on a train, say, and then suddenly everything they see out the window appears upside down but the inside of the train remains right-side up.

RR I have only worn *Upside Down Goggles* for a short time, but the effect was so disorienting as to be almost paralysing.

CH Some people can't stand it; they just look through them for an instant and then take them off. I find them helpful because they give you a way of looking in a more abstract way. To me, abstraction is one of the real achievements of art, because it's the first time that we got away from nature. We're not distorting it anymore, in one way or another, we're making our own nature, so to speak. I find that the goggles also help us to create an artificial world – not abstract, but upside down – that might free us from the dictatorship of what is given in the natural world, and how it appears to us.

The *Upside Down Goggles* become especially revealing if you look at other art with them. For a show in Düsseldorf, we managed to arrange visits to the Museum Kunstpalast, where you could wear the goggles. Even the guide was wearing them. It worked especially well with paintings by Kandinsky. I'm almost sure he became interested in abstraction by

accidently putting one of his paintings upside down in his studio. The more abstract ones look more figurative if you look at them upside down and the other way around as well.

RR Wearing your *Upside Down Goggles* is much more destabilising than simply standing on your head, say, and seeing the world upside down. I think what must really short-circuit our brains is the fact that our bodily perception is telling us that we are upright, but our vision is telling us the opposite.

CH It relates to a sense called proprioception, which allows us to place ourselves inside space and to sense the relative position of our body parts. It's a real sense that has been acknowledged by neurologists as an addition to the five major ones, but somehow it hasn't really entered into public discussion yet. The way it works is not completely understood, but it's what allows you to know, say, that you're sitting upright on a sofa. Proprioception is quite strong, so if you are standing and wearing the *Upside Down Goggles*, it's conflicting with proprioception.

RR *The Pinocchio Effect* (1994) is another work in the exhibition that subverts our sense of proprioception.

CH *The Pinocchio Effect* is based on an experiment by psychologist James Lackner who discovered that the perception of the size of your nose, which has to do with proprioception, can be changed by applying stimulation to different muscles, especially the biceps and the triceps. If you do this, you can feel that your nose is growing outwards, Pinocchio-style, or also growing inwards. I found this to be such a beautiful discovery, so I made it into a practical device that people can use.

RR Do you want people to see it as a work of art, or as a device for altering our proprioception?

CH You don't need to see it as a work of art, you can just as well see it as a simple device. The point is that it doesn't work in the same way for everybody, because some people don't feel their nose growing or shrinking. But it is also important to look at the other people who are engaging with this work, because it's not just about you thinking about the size of your nose. It's also about thinking about other people thinking about the size of their noses, even if they don't feel any change in shape.

RR A lot of your work seems to address us at the level of individual experience – it activates a physical or perceptual response that we experience internally. But you also seem very interested in how these works function as a kind of performance made by visitors that other visitors can observe.

CH My work doesn't exclude contemplation. This is a common misunderstanding. Many people think you have to use my works in order to experience them, but I think it's also possible to experience the work through other people, to see it from the outside, or to just contemplate it. It depends on who you are and how you feel.

RR This also seems to be the case with your piece *Two Flying Machines* (2015).

CH The *Two Flying Machines* place you in the air and create a unique experience of hanging in a harness while 'flying' around in circles. At the same time it's completely ridiculous, and you have people looking at you from underneath thinking, 'You're hanging there like a bag of potatoes'. Inevitably you have this funny expression on your face. So it's about being ridiculous and having a great experience at the same time.

RR Like some other works in the exhibition that also function as transport systems, it seems designed to transport you mentally as well as physically.

CH It's a machine that promotes meditation. For some reason hanging in the air like this while 'flying' in circles makes you meditate automatically.

RR *Two Flying Machines* also seems to evoke the fantasies that we have, especially as children, about being able to fly. But as you just mentioned, it is also a device for making us appear ridiculous. This mischievous aspect of your work was perhaps most evident in one of your very first works, the 'Killing Children' series from the early 1990s. What was the idea behind those works?

CH They were presenting ways of how you could capture, torture and kill children, which is maybe not something that is needed, but they would really work if you were to apply them. Of course they also functioned in another way, which was to raise questions about the

holiness of procreation. There is a real taboo about discussing the value of having children. Scepticism about this is not taken very well. My education was considerably influenced by evolutionary theory, as I mentioned before, and while I don't think we should necessarily use this theory for everything, I was interested in applying it to the question of why do we want to have children and how much is this governing our lives, and how much is it influencing our whole decision-making process.

RR Some 20 years after making the 'Killing Children' series, you have made a sculpture, *Dice (White Body, Black Dots)* (2014), which seems like a much more friendly artwork designed for children.

CH Yes. But it's maybe even meaner in a way.

RR How so?

CH Well, because it's not so obvious. It's a sculpture of a large die with holes in it that are only accessible to children, because they're the only ones small enough to pass through the holes into the interior space. The space inside is a black sphere, so it's up to you to consider what that could possibly be good for.

RR The way you just described it makes it sound like a kind of sarcophagus.

CH Or like a womb.

RR Were you also thinking about how the sculpture would be experienced by adults who can't enter it, but are watching little bodies going in and out of the holes?

CH I think all those kiddies crawling in and out of the work look like maggots in a cheese.

RR So maybe this work isn't so innocent after all.

CH Not at all, if you ask me. At first glance it looks child-friendly, an artwork that invites children to play with it and gives them a space for entertainment that is fulfilling their specific needs. At the same time, of course, especially if it's presented in a museum context, you

can see it as a viewer from the outside, as a sculpture with kids. So it's a bit like I'm using other people's kids in order to fill this sculpture with life. Also, I like the idea that it's some kind of test site for testing the intelligence of children. So it certainly works on different levels.

RR We spoke earlier about your signature gestures. I think another one of your signature gestures might be the way in which your work encourages people to respond to it in diverse ways. It seems designed to address different kinds of people, including visitors who may not have a great deal of knowledge about contemporary art.

CH Absolutely. In general I'm not trying to make artworks that express some particular view that I have about the world. I want to create some kind of tool that can be used in multiple ways, but still in quite specific ways, and often together with other people, so that it becomes something that goes beyond a focus on the 'meaningful' object. It's about making a specific proposition that everyone can use in their own specific way. I want to provide varied platforms of access, so to speak, where you can have a child behaving very differently in this exhibition compared to, say, a distinguished art connoisseur, and everyone in between. I don't want the connoisseur people to decide if it's good or bad, and the others just following them. I only fully understood the possibility of doing this when we opened the *The Double Club* (2008–09) here in London, because people used it in so many different ways.

RR As an artwork that was also a bar, a disco and a restaurant juxtaposing Congolese and Western sections, *The Double Club* must have drawn a range of audiences expecting to enjoy it in very different ways.

CH Yes, some people would hear about it as a kind of artwork and they would come in and wonder 'Where's the art?' They would see artworks hanging on the restaurant walls and then think, 'Aha, it's like an exhibition'. So you could approach it in that way, but there were many other levels that could be experienced simultaneously. You could also just go there and have a beer or a good meal.

RR You once described how a couple could be sitting at the bar and one person could be facing the Congolese side of the bar, while the other person was facing the European side, and so each person would perceive themselves in a completely different environment. On some

level that seems like an apt summary of what human interaction is often like. We think we exist in the same world, but to a significant extent we have no idea how someone else is seeing the world.

CH Strangely enough, this double-ness felt comforting, this kind of indecision between the Congolese slices and the Western slices, especially when you had a situation with people dancing and talking and eating. For some reason – which I would really like to have somebody explore in more detail – the messy double-ness feels better than if everything is laid out in order to produce some kind of more or less homogenous and therefore predictable environment.

RR Perhaps an environment like the *The Double Club* encourages us to surrender the usual effort we make to maintain a coherent or consistent façade ourselves.

CH It definitely felt like a relief. You didn't have to submit yourself to this idea of oneness, but you instead had the freedom of at least two choices, which is a relief.

RR I wonder if your own double identity as someone who first trained as a scientist and then later became an artist has helped you to make work that embraces or incorporates multiple perspectives?

CH Perhaps, but then you can also say that we all grow up with a kind of double reference because you have a mother and a father and you are the product of these two different people, even if you don't grow up with them. That's probably the first experience you have and it makes double-ness a powerful construction that is with you for the rest of your life. In my case, there was an additional double-ness because my brother and I grew up in Belgium, but with German parents. Our neighbours on the right-hand side were speaking French, and our neighbours on the left-hand side were speaking Flemish. So double-ness was something that started with mother and father, but then it expanded into all kinds of other domains. Each side of double-ness has again, of course, its own double-ness, and so on, like the logic of divisions and the asymptote we discussed earlier. Then I think it's maybe possible even to overcome double-ness and to reach out into something that is beyond it, but it may lie in infinity.

RR A number of your works seem to possess multiple identities. They can function as practical devices while simultaneously functioning as artworks. *Isomeric Slides* (2015), for instance, is a sculpture on one level, and on another it provides a means by which visitors can exit the Hayward Gallery.

CH The slide is a kind of gesture that you take out of its usual context in order to expand its range of possibilities. If you take it away from its single identity as a playground device for children, you can open up its potential, giving it a multiple identity, as you say.

RR Your earliest version of a slide was made for a show you did in 1996. What was it that first led you to think of introducing a slide into an art gallery?

CH It was part of a show called *Glück*, which in German can mean happiness, fortune and luck, all in the same word. The show was really about mood more than anything else, and the strangeness, the volatility of it. It was also an attempt to see if we could get all the visitors to be in the same mood, like when people come out of a movie theatre after watching the same film and they all have a similar expression on their faces. I have always found this to be both a very disturbing and comforting phenomenon – the way that people suddenly seem to lose their individuality and become almost like a synchronised organism. The version in *Glück* was not really a slide, it was just a little slope and people could sit on sledges and slide down it. I was amazed at how synchronised people became through this simple experience. It's almost impossible not to be. I've never seen someone coming down a slide who wasn't smiling. You have this stupid, happy expression on your face, so it's kind of humiliating in a way when people see you coming out at the end. But the first real slide was with Klaus Biesenbach at Kunst-Werke Berlin in 1998. He heard about this slope and sledge thing and misunderstood that this was a slide and wanted me to do another one. We thought right away that this was a productive misunderstanding.

RR Were you partly inspired by your memories of slides as a child?

CH When I was growing up I used to take a bus to school and every morning this bus would pass a home for the elderly, which was a red brick building standing in a lush green park, and on all four sides of it they had constructed stainless steel slides landing on the lawn. It looked

pretty absurd. I'm not 100% sure if I made this up in retrospect, but that's how I remember it. It apparently impressed me deeply. The slides were meant to save people in case the building caught on fire, of course, but I always thought, 'What a good idea', and that if I could build a house, I would want it to have slides.

RR *Isomeric Slides* descends from the Hayward's roof and, seen from outside, it definitely looks like a disconcerting appendage to the architecture. You've spoken of your slides as having a sculptural dimension, and I was wondering whether you also consider them as making a type of architectural intervention?

CH At the Hayward, *Isomeric Slides* certainly connects to the brutalist architecture of the building, although in a way that's quite different in terms of the look of it. It connects, however, in the way that it's referring to a certain attitude. From another perspective, it's like the beginning of a de Kooning painting: a few lines, a few circles, a few movements in space. Its spiralling curves introduce a moment of playfulness that stands in contrast to right-angle thinking, and maybe even the rationality of architecture and industrialisation.

By putting a work like this in a museum context, it also functions as a proposition or model for something that could be carried out on a larger architectural scale, which I think is something we should do. Slides could be everywhere, in and between buildings. We also carried out a study with architect Farshid Moussavi and she made fantastic drawings of towers that would use slides as an external skeleton to hold the building together. The entire tower is just composed of slides. There would be holes in the walls that you could enter in order to access other floors, and an elevator in the middle.

RR Is there any other type of slide construction that you would like to see realised?

CH I would like to make a slide that is really, really long so that you would have time to read and to eat and drink on the way down. That would give you the amount of time that you would need to reflect upon the situation that you're in, because you're not able to do that with the slides that I have made so far. It's too short a ride.

RR That's a very interesting idea – especially since you have described the experience of going down a slide as being almost like a kind of

delirium – that sense of being carried away and of being out of control, even though the end result is not a surprise.

CH Yes, it's almost like a way to gain access to another world or realm of experience. In this sense I think the slide is quite helpful, because it allows you to experience a short moment of real madness when you're going down, which is repeatable and predictable, but still very effective, and it stays with you as a kind of memory reference point. So I think it's a good device or tool to free yourself from the usual ways you have at your disposal to look at the world and, even if it only lasts a few seconds, to maybe start again from somewhere else.

RR By placing a slide in a museum, you give people a chance to experience it in a different way than they might do in a playground or amusement park. At the same time, it offers an opportunity for a turbulent physical experience that seems almost the opposite of the composed contemplation that the museum was originally designed to accommodate.

CH Yes, but first of all most museums are not really like this anymore. Going to museums and art exhibitions has become a very popular thing to do, and so you are always with other people. It's not like it was back in 1991 when I went to see the Rothko Chapel in Houston. I was still working as a scientist at that time, and I was there alone, and I had a profound experience, or to be honest I have to say that at least I knew that I was supposed to have a profound experience and I came close to having it. But I haven't really had that since in a museum. It's something that is supposed to be there, but it's very, very hard to find. So maybe the slide is actually a more effective way of producing a profound moment – not just by looking at something, but by giving you this approach of bringing a moment of transcendence into your life.

RR Some critics have argued in the past several years that pleasurable forms of participatory art have become a kind of mass entertainment, an art world equivalent to what has been called 'the experience economy'. From this perspective, the participatory art of the 1960s and 1970s achieved something significant by disrupting staid conventions of how we behave in galleries, but now that people have come to expect this kind of experience in museums, it no longer has any meaningful subtext. It just becomes empty play. What is your response to this kind of critique?

CH You shouldn't forget that I see myself as a kind of entertainer also. People are coming to see the show because they know I'm going to entertain them in a special way, which is not comparable to other forms of entertainment. Personally I think it's wrong to condemn entertainment in art because that's just giving it all away to the enemy. This is a common capital that we have and there's no reason why we should give it away like this. If you don't understand the value of entertainment, you haven't understood much about life.

RR For many art critics, 'entertainment' seems to be a dirty word.

CH I am interested in trying to give entertainment a new value, to bring it out of this 'dirty' context, because I don't think it belongs there. I think a Rothko show is ultimately as entertaining as an experience-based show. There is really no difference, so it's time to think in new ways about the varied qualities of experience. We want to produce unique experiences with art that the experience economy cannot produce. It's time to radicalise experience and make it into something more disturbing or painful, if you want an experience that contains, as I said before, embarrassment, humiliation, all these other forces that are used to make it more complex.

RR I agree that there's a profound history of art being entertaining in the sense of it deeply engaging people and involving them in a process of entertaining new ideas and propositions.

CH I also think it's important to consider entertainment as a key factor in terms of taking decisions. Very often, if you have a decision to make, you're choosing the one that is maybe least painful and most entertaining. So entertainment is an incredible driving force in our lives. Entertainment does not just exist in its most basic forms; there is also sophisticated entertainment, and very engaged forms of entertainment. Food is entertainment, music is entertainment and art is entertainment too. It is an eerie force in our lives that not many seem to question, even though it's such a common, decision-making force. It's eerie because of it's ability to hide behind the 'What am I good for?' question, as it doesn't reveal it's own utility. It governs our lives while at the same time being extremely hard to grasp.

RR Which brings us to the title of your exhibition.

CH Yes. Very often you take decisions in order to avoid something harmful or potentially dangerous, but you also take decisions because you want to maximise some benefit or gain, which could very well be something that has to do with your own personal happiness. So in this sense a work like *Isomeric Slides* also contributes to asking questions about what this really is. What kind of force is this that makes us take these kinds of decisions without it ever becoming really clear? What kinds of mechanics are behind this phenomenon? It's something that we almost take for granted, because we can't really think about it. You also wonder, on a more profound level maybe, what is the driving force behind our ceaseless search for entertainment and fun. This is something that we consider to be almost primitive, but it may have a stronger influence on us than we care to acknowledge. It's a thing that makes us decide. It's very unclear, I believe, so it's a challenging question to look at.

RR Your art often seems to encourage visitors to engage with and even embrace a position of uncertainty – not to make decisions but to inhabit a space in between decisions.

CH There's really a common theme there in all of these works. They are all methods for taking away what we take for granted, in order to make the ground a bit more loose, to destabilise you or free you from this dictatorship of the predictable. I think this also introduces a strong notion of freedom.

RR Is the freedom you are referring to a freedom from having to make decisions?

CH Yes. I think this is the ultimate luxury. Luxury has been such a strong concept, especially in recent years, but we're still looking at it in terms of material luxury. Spiritual luxury is something we don't have any clear idea of how to deal with or what it could even be. We might relate it to an idea of tranquillity or some vague notion about Zen Buddhism. But what about something much more related to our own culture? For me, freedom from taking decisions would be the ultimate spiritual luxury.

RR Of course, on one level the capacity to make decisions is something we associate with freedom. It's what is taken away from you, say, in a totalitarian society.

CH Or in a prison. Obviously that's not what I have in mind.

RR So your idea of spiritual luxury is more about maintaining a state of open-mindedness, of refraining from decision-making in order to remain available to different possibilities?

CH Yes, it's against the all-encompassing dominance of time, predictability, necessity – and all these things that we needed to get under control in order to make our lives better in one way or another. Now we could have the luxury of getting away from that.

RR Yet as an artist you're constantly making decisions, and I imagine that some of those decisions give you pleasure because you enjoy what you do.

CH Yes, well that's why I make them. But I also find it rewarding to think about non-decision-making or indecision as another kind of pleasure-producing principle. Ultimately, it's about seeing if the structures that contain our decision-making are really so necessary, or if there's another way to look at our situation. I don't know the answer to this, but I'm proposing that we look for it.

For a long time, I've been curious about applying the methodology of art as one way – which I think is equal to science and other powerful explanatory concepts – for us to understand what is surrounding us and what we are. We still don't know very much about the mind, or reason, or intention, or value, or entertainment. We don't even know about life. We don't know what this is. So we still have very big open questions that we don't know how to deal with because they are not explained by science or philosophy or religion in a satisfactory way.

RR Given that so much of your work deals with very subjective experiences, it poses a challenge in terms of how it can be discussed 'objectively'. The other day you mentioned that it was really impossible to talk about your art and yet we've been discussing it here at considerable length, so I am wondering if there remains some aspect of the work that you feel you really can't put into words?

CH I'm happy that you mention this, because it's important to say this in the context of what we're doing with this conversation. These works are against language, against the hegemony of the written and spoken word as a way for us not only to communicate, but also to

understand. I think we all agree on the fact that language has a structure, and that's how it works. It's linear to some extent. It cannot deal with a certain level of complexity if it is not allowed to explore it over a certain amount of time. With art, on the other hand, you can deal with complexity in a more immediate way. So we must be clear about the fact that what we have discussed here is only what you can speak about, but that there's also something else. It's not that we don't have the words for it, but that the words will never be there, because they're organised in a different way. This is something that we all know, I'm sure, from the moment that we are conscious and can talk. But we become so used to language that we sometimes forget about its limitations and how it makes us see the world in a certain way.

In the end, it's probably impossible to really describe in words anything that has to do with experience. It's what in consciousness-related research is called 'the hard problem'. You can say, 'There are all these neurons firing together and that means there's a certain state of alertness', but that has nothing to do with what we experience when we are conscious. So there is an explanatory deficit, which is created not only because the models, or ideas, or explanations that we have are lacking in some way, but also because of language itself, I would say. But through art we have another approach which can be beyond language. That's where its real value lies.

Interview conducted in three sessions – two in person,
one over the phone – in London and Stockholm, March 2015

LIST OF WORKS

Measurements are given in centimetres, height × width × depth
All works are © the artist, unless otherwise stated

7,8 Hz (Reflective Concrete), 2015
Reflective paint, modified Litepanels Sola12, PIC controllers
Dimensions variable
Courtesy the artist

A B Sign, 2015
Acrylic glass, vinyl, LED lights, electric motor, control unit, steel,
MDF, motion sensor
50 × 50 × 30
Courtesy the artist

Adjusted Hayward Sign, 2015
Aluminium letters painted white, keyline silver vinyl, LED lights,
LED transformer
40 × 700 × 6
Courtesy the artist

Decision Corridors, 2015
Galvanised steel, steel scaffolding
2 parts, each length: *c.*7,500
Courtesy the artist. Produced in cooperation with HangarBicocca,
Milano

Dice (White Body, Black Dots), 2014
Polystyrene, epoxy, paint, glass reinforced polyester resin/fibreglass
and plywood on polystyrene core, mechanical connectors
240 × 240 × 240
Courtesy Gagosian Gallery

Divisions (Wall Painting with Aphids), 2015
Vinyl emulsion paint, steel
Aphid: length 65
Courtesy the artist and Massimo De Carlo, Milan

Fara Fara, 2014
with Måns Månsson
2-channel video installation of digitised 35mm film and archival VHS
material, colour, sound
13 mins
Courtesy the artists

Flying Mushrooms, 2015
Polyester mushroom replicas, polyester paint, synthetic resin, acrylic
paint, wire, putty, polyurethane, rigid foam, stainless steel
Diameter: *c*.900
Courtesy the artist. Produced in cooperation with HangarBicocca,
Milano

The Forests, 2002/15
Virtual reality goggles, computer, reset button
4 mins
Courtesy the artist and Air de Paris, Paris

Half Clock, 2014
Neon-filled glass tubes, cables, stainless steel, acrylic glass,
DMX boxes, control unit
Diameter: 80
Thyssen-Bornemisza Art Contemporary, Vienna

Half Mirror Room, 2008/15
Mirrors, stainless steel trim, wood
Overall installation: half the wall surface of the exhibition space
Each mirror panel: 225 × 200
Courtesy the artist

Isomeric Slides, 2015
Stainless steel, polycarbonate, steel
2 parts, each: 1,565 (height)
Courtesy the artist and LUMA Foundation, Arles

Memory Game and Table, 2013
With Attilio Maranzano
Printed cardboard, aluminium, dibond, steel, belt
Memory Game laid out: 148.5 × 196.3; table installed: 80 × 180 × 180
Courtesy the artist and Air de Paris, Paris

Phi TV, 2007
Two flat-screen TVs, two digital video broadcasting receivers,
control units, cables
Dimensions variable
Courtesy the artist and Air de Paris, Paris

Phi Wall II, 2002
White and brown neon-filled glass tubes, acrylic glass, colour filters,
aluminium, wood, control unit, cables
96 discs; each: 56 (diameter)
Courtesy the artist

Pill Clock, 2011/15
Gelatine capsules, placebo, mechanical drop mechanism, control
unit, acrylic box, water dispenser
Drop mechanism: 50 × 42 × 38; acrylic box: 70 × 70 × 90;
pills each: 2 × 0.5
Courtesy the artist and Micheline Szwajcer Gallery, Brussels.
Produced in collaboration with Fundación Botin

The Pinocchio Effect, 1994
Electric medical vibrators, cables, photographic print of drawings
on paper, steel, wood, glass
2 parts, each: 80 × 67 × 58
Courtesy the artist and Air de Paris, Paris

Reflections On Her Eyes, Reflections On My Eyes, 1996/2015
Photographic print, acrylic glass, aluminium
2 parts, each: 70 × 101
Courtesy the artist and Micheline Szwajcer Gallery, Brussels

Snake, 2014
Polyurethane, glass eyes
18 × 174 × 60
Courtesy Air de Paris, Paris and Gagosian Gallery

*Twins (Belgian, London, New York, Paris, Santiago de Chile, Tokyo,
Vienna)*, 2005–15
14 monitors, 14 media players, cables, metal
14 parts, each: 180 × 47 × 47; variable (looped)
Courtesy the artist; Micheline Szwajcer Gallery, Brussels;

Gagosian Gallery, London; Air de Paris, Paris; Die Ecke
Arte Contemporáneo, Santiago de Chile; ShugoArts, Tokyo;
Thyssen-Bornemisza Art Contemporary, Vienna

Two Flying Machines, 2015
Galvanised steel, electric motors, cable connections, paragliding
harnesses, motorcycle grips, wood, control units
Footprint: *c*.800 × 800; height: 500; operating radius: 310; height
of flight: *c*.300
Courtesy the artist and Gagosian Gallery

Two Roaming Beds (Grey), 2015
Painted steel, electric motors, 3D printed nylon, rubber tyres,
cables, electronics, LED lamp, acrylic glass, phone chargers,
mattresses, linen, ink, pens
2 parts, each: *c*.130 × 210 × 100
Speed: 0.7 metres per min
Courtesy the artist. Produced in cooperation with Bonniers
Konsthall, Stockholm, and HangarBicocca, Milano

Upside Down Goggles, 1994/2009
Acrylic glass prisms, aluminium, polyethylene, polypropylene, foam,
leather, nylon
14 goggles, each: 13 × 30 × 24
Courtesy the artist

W Z Sign, 2015
Acrylic glass, vinyl, LED lights, electric motor, control unit, steel,
MDF, motion sensor
50 × 50 × 30
Courtesy the artist

X Y Sign, 2015
Acrylic glass, vinyl, LED lights, electric motor, control unit, steel,
MDF, motion sensor
50 × 50 × 30
Courtesy the artist

LIST OF LENDERS

The following individuals and institutions have kindly lent to the exhibition:

Air de Paris, Paris
Gagosian Gallery
Francesca von Habsburg,
 Thyssen-Bornemisza Art Contemporary, Vienna

ACKNOWLEDGEMENTS

In addition to those already thanked in the foreword, Southbank Centre is grateful to all the following institutions for their immense assistance, support and contribution to the exhibition:

Air de Paris, Paris
Massimo De Carlo, Milan/London

Phil Arnold, Infinite Possibilities Strategist, Interactive Agents
Sara Arrhenius, Director, Bonniers Konsthall
Chloe Barter, Gagosian Gallery
Andrew Bonacina, Curator, Monsoon Art Collection
Matt Bowler, Sales Director, Vantage
Kate Brownbill, Registrar, Gagosian Gallery
Géraldine Convert, Artist Liason, Air de Paris
Simeon Corless, Partner, KS Objectiv
David Derby, Partner, Price & Myers
Felix Dickinson, Amat Amas Amo
Ashley Elliot, The Whitewall Company
Sam Forster, Sam Forster Ltd
Mark Francis, Director, Gagosian Gallery
Yves Gaumetou
Detlev Gregorczyk
Benjamin Hargrave
Graham Harman, Director, Highline
Patrick Hartung, Josef Wiegand GmbH & Co.KG
Lasse Hässler, Prototal
James Heaney, Structural Engineer, Specialized Designs Limited
Neshah Hines, Actress

Nyah Hines, Actress
Thomas Huesmann, MixedMedia Berlin
Michael Kretschmer, Project Manager,
 Josef Wiegand GmbH & Co.KG
Silvana Lagos, Carsten Höller Studio
Camilla Larsson, Curator, Bonniers Konsthall
Melissa Lazarov, Gagosian Gallery
Volker Leppers, Grieger
Lars Mandler, Präparationsatelier + Ausstellungsgestaltung
Anna Nesbit
Göran Nordahl, Loligo
Paul Padoan, Prototal
Iñigo Sáenz de Miera Cárdenas, Director, Fundación Botín
Attila Saygel, Saygel & Schreiber
Lorenz Schreiber, Saygel & Schreiber
Uwe Schwarzer, MixedMedia Berlin
Roberta Tenconi, Curator, HangerBicocca
Vicente Todoli, Artistic Director, HangerBicocca
Mark Tyler, Associate, Price & Myers
Benjamin Weil, Director Artístico, Fundación Botín
Stephanie Wilkins, Delvendahl Martin Architects

In addition to those named in the foreword, thanks are also given
to those staff at Hayward Gallery and Southbank Centre for their
contributions to the realisation of *Carsten Höller: Decision*:

Diana Adell, Publications Coordinator, Hayward Publishing
Bode Akanbi, Health and Safety Specialist
Matt Arthurs, Installation Technician
Vaughan Bhagan, Visitor Experience Manager
Lucy Biddle, Interpretation Manager
Harriet Black, Press Officer
Charlotte Booth, Assistant Registrar
Alison Bowyer, Head of Grants and Trusts
Ali Brikci-Nigassa, Security Team
Lisa-Marie Brown, Website Manager
Andrew Caddy, Arts Business Partner
Nick Cain, Design and Production Manager
Jai Campbell, Infrastructure Solutions Engineer
Sarah Cashman, Hayward Administrator

Marcia Ceppo, Operations Coordinator
Lorraine Cheesmur, former Visitor Experience Manager
Steve Clark, Merchandising Assistant
James Coney, Senior Installation Technician
Murray Cooper-Melchiors, Head of Ticketing and Contact Centre
James Cowdery, Head of Digital Engagement
Melford Deane, Company Secretary and Legal Adviser
Janet DeLuca, Security Team
Chris Denton, Director of Marketing and Communications
Helen Faulkner, Marketing Manager
Charlotte Flint, Administrative Assistant
Matt Freeman, Patrons Manager
Catherine Gaffney, Staff Editor, Hayward Publishing
Alison Gannagé-Addison Atkinson, Commercial Events Manager
Philip Gardner, Senior Installation Technician
Alex Glen, Publication Sales Officer, Hayward Publishing
Matthew Hale, Head for Visitor Experience
Gareth Hughes, Senior Installation Technician
Rob Hunter, GBM
Nicola Jeffs, former Press Manager
Rukhsana Jahangir, PA to Director of Hayward Gallery
Mark King, Senior Installation Technician
Debra Lennard, Curatorial Assistant
Thomas Malcherczyk, Hayward Gallery Operations Manager
Alison Maun, Bookings and Transport Administrator
Filipa Ferreira Mendes, former Press Officer
Hannah Morrison, Grants and Trusts Officer
Nicola Muir, Marketing Officer
Khadeen O'Donnell, Corporate Development Manager
Kevin Parker, Estates and Facilities
Kate Parrott, Installation Technician
Sarah Ross, Interim Buying and Merchandising Manager
Eddy Smith, Technical Director
Ros Sorrentino, Duty Manager, Visitor Experience
Eleanor Stevenson, Senior Graphic Designer
Steve Thompson, Digital Display Producer
Hilton Wells, Head of Technical Services (Estates and Facilities)
Shauna Wilson, Health and Safety Assistant
Imogen Winter, Registrar
Fergus Wright, former Health and Safety Specialist
Helena Zedig, Deputy Head of Press

Published on the occasion of the Hayward Gallery exhibition

Carsten Höller: Decision
10 June – 6 September 2015

Exhibition curated by Ralph Rugoff
Assistant Curators: Dina Ibrahim and Rahila Haque
Curatorial Assistant: Charlotte Baker

Generously supported by

LUMA
FOUNDATION

The Henry Moore
Foundation

Hotel partner

MONDRIAN
LONDON
...................................
AT SEA CONTAINERS

This exhibition has been made possible by the provision of insurance
through the Government Indemnity Scheme. Hayward Gallery
would like to thank HM Government for providing Government
Indemnity and the Department of Culture, Media and Sport and
Arts Council England for arranging the indemnity.

Published by Hayward Publishing
Southbank Centre
Belvedere Road
London SE1 8XX
www.southbankcentre.co.uk

Art Publisher: Ben Fergusson
Sales Officer: Alex Glen
Staff Editor: Catherine Gaffney
Press & Marketing Coordinator: Diana Adell

Catalogue designed by Wayne Daly

Printed in Spain by Grafos S.A.
© Southbank Centre 2015
Texts © the authors 2015

A catalogue record for this book is available from the British Library
ISBN 978-1-853323-32-4

This catalogue is not intended to be used for authentication or
related purposes. The Southbank Board Ltd accepts no liability for
any errors or omissions this catalogue may inadvertently contain.

Distributed in North America, Central America and South America
by D.A.P. / Distributed Art Publishers, Inc.
155 Sixth Avenue, 2nd Floor, New York, NY 10013
Tel: +1 212 627 1999
Fax: +1 212 627 9484
www.artbook.com

Distributed in the UK and Europe by Cornerhouse Publications,
HOME, 2 Tony Wilson Place, Manchester, M15 4FN
Tel: +44 (0)161 212 3466
Fax: +44 (0)161 212 3468
www.cornerhousepublications.org/books